*A Short Guide
to Writing
about Art*

The Short Guide Series

UNDER THE EDITORSHIP OF

Sylvan Barnet
Marcia Stubbs

A Short Guide to Writing about Literature by Sylvan Barnet
A Short Guide to Writing about Biology by Jan A. Pechenik
A Short Guide to Writing about Social Science by Lee J. Cuba
A Short Guide to Writing about Film by Timothy Corrigan
A Short Guide to Writing about Art by Sylvan Barnet
A Short Guide to Writing about History by Richard Marius

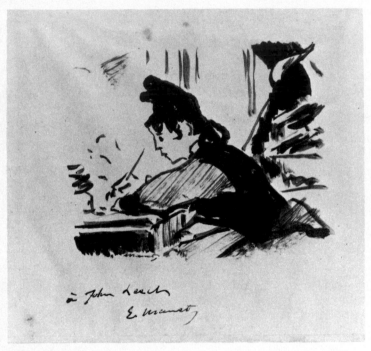

Edouard Manet, *Woman Writing,* brush and black ink 5⁹⁄₁₆″ × 6¼″.
Copyright 1982 Sterling and Francine Clark Art Institute, Williamstown,
Mass. Reproduced by permission.

A Short Guide to Writing about Art

THIRD EDITION

SYLVAN BARNET
Tufts University

HarperCollins*Publishers*

Library of Congress Cataloging-in-Publication Data

Barnet, Sylvan.
A short guide to writing about art.

Bibliography: p.
Includes index.
1. Art criticism—Authorship. I. Title.
N7476.B37 1989 808'.0667 88-15641
ISBN 0-673-39667-3

8 9 10 94 93 92

Printed in the United Kingdom.

Acknowledgments

"Millet's *The Gleaners*" (pp. 6–7), by Robert Herbert, reproduced from
the exhibition catalogue *Man and His World: International Fine Arts Exhi-
bition*. © The National Gallery of Canada for the Corporation of the National
Museums of Canada. Reprinted by permission of The National Gallery of
Canada and Robert L. Herbert.

Quotation and drawing (pp. 17–18) from Rudolf Arnheim, *Art and Visual
Perception* (1974). Reprinted by permission of the University of California
Press.

"Mrs. Mann and Mrs. Goldthwait" (pp. 73–83) by Rebecca Bedell. Copy-
right © 1981 by Rebecca Bedell. Used by permission of the author.

"Two Low Relief Carvings from the Fifteenth Century" © Oxford Uni-
versity Press 1964. Reprinted from *Relief Sculpture* by L. R. Rogers (1964)
by permission of Oxford University Press.

Quotation from *Gothic* by George Henderson (Harmondsworth, England:
Penguin Books Ltd., 1967), p. 43. Copyright © George Henderson, 1967.
Repritned by permission of Penguin Books Ltd.

Excerpt (pp. 121–22) from *Purposes of Art*, Third Edition, by Albert E.
Elsen. Copyright © 1972 by Holt, Rinehart and Winston, Inc., by per-
mission of the publisher.

Excerpts from *International Handbook of Contemporary Developments in
Architecture*, ed. Warren Sanderson. Copyright © 1981 by Warren Sanderson.
Reprinted by permission of Greenwood Press, Westport, CT.

Preface

Another book for the student of art to read? I can only echo William James's report of the unwed mother's defense: "It's such a *little* baby." The title and the table of contents adequately reveal the subject of this book; if the chapters themselves fail to please and instruct, and if the ten questions listed on the inside front cover do not help to produce better essays, no preface will avail.

Still, a few additional words may be useful. Everyone knows that students today do not write as well as they used to. Probably they never did, but it is a truth universally acknowledged (among English teachers) that the cure is *not* harder work from instructors in composition courses; rather, the only cure is a demand, on the part of the entire faculty, that students in all classes write decently. But instructors outside of departments of English understandably say that they lack the time — and perhaps the skill — to teach writing in addition to, say, art. This book may offer a remedy. Students who read it — and it is short enough to be read in addition to whatever readings the instructor regularly requires — should be able to improve their essays, partly by studying the principles explained (e.g., on tone, paragraphing, and manuscript form) and partly by studying the short models throughout the book. It contains three essays by students, two by professors, and numerous paragraphs from published scholars such as Rudolf Arnheim, Albert Elsen, Anne Hollander, Meyer Schapiro, and Leo Steinberg. These discussions should help students to understand the sorts of things one says, and the ways one says them, when writing about art. After all, people *do* write about art, not only in the classroom but in learned journals, catalogs, and even in newspapers and magazines.

The first few pages of the book try to explain *why* one writes about art, but on this topic I would like to add one quotation. The late Harold Rosenberg said:

> The art critic is the collaborator of the artist in developing the culture of visual works as a resource of human sensibility. His basic function is to extend the artist's act into the realms of meaningful discourse.
>
> *Art on the Edge* (New York: Macmillan, 1975), p. 142

Finally, I gladly acknowledge my numerous heavy debts. I cannot begin to list all of the scholars from whose works I have profited over the decades, but I must at least say that some of my thoughts on the difficult yet fundamental matter of defining style are greatly indebted to four writers: James Ackerman, *Art and Archaeology* (1963); Monroe Beardsley, *Aesthetics* (1958); E. H. Gombrich, "Style," in *International Encyclopedia of the Social Sciences* (1968); and Meyer Schapiro, in *Anthropology Today,* edited by A. L. Kroeber (1953).

I am glad that I have this opportunity to thank James Cahill, Madeline Harrison Caviness, Ivan Galantic, Robert Herbert, Naomi Miller, and Elizabeth deSabato Swinton for showing me some of their examinations, topics for essays, and guidelines for writing papers. I have received invaluable help of another sort from those who read part or all of my manuscript: Howard Barnet, Peter Barnet, Morton Berman, William Burto, Ruth Butler, James Cahill, Charles Christensen, Fumiko Cranston, Joan Feinberg, Julius Held, Eugene J. Johnson, Susan Kuretsky, Jody Maxmin, Lawrence Nees, John Rosenfield, Marcia Stubbs, Gary Tinterow, and Stephen Urice called to my attention omissions, excesses, infelicities, and obscurities. I have not hesitated to adopt many of their suggestions verbatim. I am further indebted to Marcia Stubbs for letting me use some material that had appeared in a book we collaborated on, *Barnet & Stubb's Practical Guide to Writing.* Joe Opiela and Cynthia Chapin (at Scott, Foresman/Little, Brown College Division) and Scott Huler have been consistently helpful and tolerant in enabling me to turn a manuscript into a book. I am also indebted to myself; in *A Short Guide to Writing about Literature* I tried out some of the ideas that appear here in a revised form.

A Note on the Third Edition

Many pages have been revised, most conspicuously in Chapter 2, "Analysis," where I have added many questions (especially on architecture) that students can ask themselves in order to generate responses to works of art. (Andy Warhol said that in America most people think that Art is a man's name.) These responses will usually increase a student's understanding of art and will therefore also reduce a student's terror of blank sheets of paper. Asking questions will not in itself produce well-written essays (other chapters address themselves to that business), but it will help to produce thoughtful essays. The chapter on the research paper has also been substantially revised, and five illustrations have been added to the twenty-five illustrations of the previous edition.

Contents

1
Writing about Art

WHY WRITE?

We write about art in order to clarify and to account for our responses to works that interest or excite or frustrate us. In putting words on paper we have to take a second and a third look at what is in front of us and at what is within us. And so writing is a way of learning. The last word is never said about complex thoughts and feelings — and works of art, as well as responses to them, embody complex thoughts and feelings — but when we write we hope to make at least a little progress in the difficult but rewarding job of talking about our responses. We learn, and then we hope to interest our reader because we are communicating our responses to material that for one reason or another is worth talking about.

But to respond sensitively to anything and then to communicate responses, we must have some understanding of the thing, and we must have some skill at converting responses into words. This book tries to help you to deepen your understanding of art — what art does and the ways in which it does it — and it also tries to help you transform your responses into words that will let your reader share your perceptions, your enthusiasms, and even your doubts. This sharing is, in effect, teaching. Students often think that they are writing for the teacher, but this is a misconception; when you write, *you* are the teacher. An essay on art is an attempt to help someone to see the work as you see it.

THE WRITER'S AUDIENCE

If you are not writing for the teacher, for whom are you writing? For yourself, of course, but also for an audience that you must imagine. All writers need to imagine some sort of audience — high school students or lawyers or readers of *Time* or professors of art history — and the needs of one imagined audience are not the same as the needs of another. That is, writers must imagine their audience so that they can decide how much information to give and how much can be taken for granted. In general, think of your audience as your classmates. If you keep your classmates in mind as your audience, you will not write, "Leonardo da Vinci, a famous Italian painter," because such a remark offensively implies that the reader does not know Leonardo's nationality or trade. You might, however, write, "Leonardo da Vinci, a Florentine by birth," because it's your hunch that your classmates do *not* know that Leonardo was born in Florence, as opposed to Rome or Venice. And you *will* write, "John Butler Yeats, the expatriate Irish painter who lived in New York," because you are pretty sure that only specialists know about Yeats. Similarly, you will not explain that the Virgin Mary was the mother of Jesus, but you probably will explain that St. Anne was the mother of Mary.

THE FUNCTION OF CRITICAL WRITING

In everyday language the most common meaning of criticism is "finding fault," and to be critical is to be censorious. But a critic can see excellences as well as faults. Because we turn to criticism with the hope that the critic has seen something we have missed, the most valuable criticism is not that which shakes its finger at faults but that which calls our attention to interesting matters going on in the work of art. In the following statement W. H. Auden suggests that criticism is most useful when it calls our attention to things worth attending to. He is talking about works of literature, but we can easily adapt his words to the visual arts.

What is the function of a critic? So far as I am concerned, he can do me one or more of the following services:

1. Introduce me to authors or works of which I was hitherto unaware.
2. Convince me that I have undervalued an author or a work because I had not read them carefully enough.
3. Show me relations between works of different ages and cultures which I could never have seen for myself because I do not know enough and never shall.
4. Give a "reading" of a work which increases my understanding of it.
5. Throw light upon the process of artistic "Making."
6. Throw light upon the relation of art to life, to science, economics, ethics, religion, etc.

The Dyer's Hand
(New York: Random House, 1963), pp. 8–9

The emphasis on observing, showing, illuminating, suggests that the function of critical writing is not very different from the common view of the function of literature or art. The novelist Joseph Conrad said that his aim was "before all, to make you *see*," and the painter Ben Shahn said that in his paintings he wanted to get right the difference between the way a cheap coat and an expensive coat hung.

Take Auden's second point, that a good critic can convince us — show us — that we have undervalued a work. Most readers can probably draw on their own experiences for confirmation. Still, an example may be useful. Rembrandt's self-portrait with his wife (page 4), now in Dresden, strikes many viewers as one of his least attractive pictures: The gaiety seems forced, the presentation a bit coarse and silly. Paul Zucker, for example, in *Styles in Painting,* finds it "over-hearty," and John Berger, in *Ways of Seeing,* says that "the painting as a whole remains an advertisement for the sitter's good fortune, prestige, and wealth. (In this case Rembrandt's own.) And like all such advertisements it is heartless." But some scholars have pointed out, first, that this picture may be a representation of the Prodigal Son, in Christ's parable, behaving riotously, and, second, that it may be a profound representation of one aspect of Rembrandt's marriage. Here is Kenneth Clark on the subject:

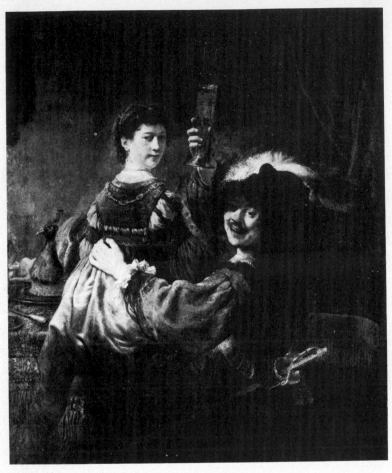

Rembrandt, *Self-Portrait with Saskia,* ca. 1635. Oil on canvas, 5′4″ × 4′4″. Gemäldegalerie, Dresden.

The part of jolly toper was not in his nature, and I agree with the theory that this is not intended as a portrait group at all, but as a representation of the Prodigal Son wasting his inheritance. A tally-board, faintly discernible on the left, shows that the scene is taking place in an inn. Nowhere else has Rembrandt made himself look so deboshed, and Saskia is enduring her ordeal with complete detachment — even a certain hauteur. But beyond the ostensible subject,

the picture may express some psychological need in Rembrandt to reveal his discovery that he and his wife were two very different characters, and if she was going to insist on her higher social status, he would discover within himself a certain convivial coarseness.

An Introduction to Rembrandt
(New York: Harper & Row, 1978), p. 73

After reading these words we may find that the appeal of the picture grows. Clark does not, of course, present an airtight case — one rarely can present such a case when writing about art — but notice that he does not merely express an opinion or report a feeling. He offers evidence (the tally-board, and the observation that no other picture shows Rembrandt so "deboshed"), and the evidence is sufficiently strong to make us take another look at the picture. After looking again, we may come to feel that we have undervalued the picture.

A SAMPLE ESSAY

Kenneth Clark's paragraph, quoted a moment ago, comes from one of his two books on Rembrandt. Clark's audience was not limited to art historians, but it was, of course, limited to the sort of person who might read a book about Rembrandt. The following essay on Jean-François Millet's *The Gleaners,* written by Robert Herbert, was originally a note in the catalog issued in conjunction with the art exposition at the Canadian World's Fair, Expo 67. Herbert's audience thus is somewhat wider and more general than Clark's. Given his audience, Herbert reasonably offers not a detailed study of one aspect of the painting, say, its composition; rather, he performs most of the services that on page 3 Auden says a critic can perform. In this brief essay, in fact, Herbert skillfully sets forth material that might have made half a dozen essays: Millet's life, the background of Millet's thought, Millet's political and social views, the composition of *The Gleaners,* Millet's depiction of peasants, Millet's connection with later painters. But the aim is always to make us *see*. In *The Gleaners* Millet tried to show us certain things, and now Robert Herbert tries to show us — tries to make us see — what Millet was doing and how he did it.

Millet's The Gleaners

Robert Herbert

Jean-François Millet, born of well-to-do Norman peasants, be-
gan his artistic training in Cherbourg. In 1837 he moved to Paris
where he lived until 1849, except for a few extended visits to Nor-
mandy. With the sounds of the Revolution of 1848 still rumbling,
he moved to Barbizon on the edge of the Forest of Fontainebleau,
already noted as a resort of landscape painters, and there he spent the
rest of his life. One of the major painters of what came to be called
the Barbizon School, Millet began to celebrate the labors of the peas-
ant, granting him a heroic dignity which expressed the aspirations
of 1848. Millet's identification with the new social ideals was a result
not of overtly radical views, but of his instinctive humanitarianism
and his rediscovery in actual peasant life of the eternal rural world
of the Bible and of Virgil, his favorite reading since youth. By ele-
vating to a new prominence the life of the common people, the rev-
olutionary era released the stimulus which enabled him to continue
this essential pursuit of his art and of his life.

 The Gleaners, exhibited in the Salon of 1857, presents the very
poorest of the peasants who are fated to bend their backs to gather
with clubbed fingers the wisps of overlooked grain. That they seem
so entirely wedded to the soil results from the perfect harmony of
Millet's fatalistic view of man with the images which he created, by
a careful disposition of lines, colors, and shapes. The three women
are alone in the bronzed stubble of the foreground, far removed from
the bustling activity of the harvesters in the distance, the riches of
whose labors have left behind a few gleanings. Millet has weighted
his figures ponderously downward, the busy harvest scene is literally
above them, and the high horizon line which the taller woman's cap
just touches emphasizes their earth-bound role, suggesting that the
sky is a barrier which presses down upon them, and not a source of
release.

 The humility of primeval labor is shown, too, in the creation
of primitive archetypes rather than of individuals. Introspection such
as that seen in Velázquez' *Water Carrier of Seville,* in which the three
men are distinct individuals, is denied by suppressing the gleaners'
features, and where the precise, fingered gestures of La Tour's *Saint
Jerome* bring his intellectual work toward his sensate mind, Millet
gives his women clublike hands which reach away from their bent
bodies toward the earth.

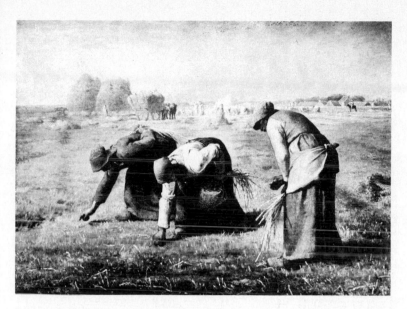

Jean-François Millet, *The Gleaners,* 1857. Oil on canvas, 32⅞″ × 43¼″. The Louvre, Paris.

It was, paradoxically, the urban-industrial revolution in the nineteenth century which prompted a return to images of the preindustrial, ageless labors of man. For all their differences, both Degas and Van Gogh were to share these concerns later, and even Gauguin was to find in the fishermen of the South Seas that humble being, untainted by the modern city, who is given such memorable form in Millet's *Gleaners.*

In this essay there is, of course, **evaluation,** or judgment, as well as analysis of what is going on in the painting. First, the writer judged Millet's picture to be worth talking about. Second, in his essay he explicitly praises some of its qualities ("perfect harmony," "memorable form"); but note that most of the evaluation is implicit in and subordinate to the **analysis** of what the writer sees. (For the moment we can define analysis as the separation of the whole into its parts; the second chapter of this book is devoted to the topic.)

The essayist sees things and calls them to our attention as worthy of note. He points out the earthbound nature of the women, the difference between their hands and those of Saint Jerome (in another picture that was in the exhibition), the influence of the Bible and of Virgil, and so forth. It is clear that he values the picture, and he states some of the reasons he values it; but he is not worried about whether Millet is a better artist than Velázquez, or whether this is Millet's best painting. He is content to help us see what is going on in the picture.

Or at least he seems to be content to help us see. In fact, of course, he tries to *persuade* us that what he sees is what is going on. And he sees with more than his eyes: Memories, emotions, and value systems help him to see, and his skill as a writer helps him to persuade us of the accuracy of his report. If he wants to convince us and to hold our interest, he has to do more than offer random perceptions; he has to present his perceptions coherently.

Let's look for a moment at the **organization,** or plan, of this essay. In his effort to help us see what is going on, the author keeps his eye on his subject.

1. The opening paragraph includes a few details (e.g., the fact that Millet was trained in Cherbourg) that are not strictly relevant to his main point (the vision embodied in the picture), but that must be included because the essay is not only a critical analysis of the picture but an informative headnote in a catalog of an exhibition of works by more than a hundred artists. Even in this preliminary biographical paragraph the writer moves quickly to the details closely related to the main business: Millet's peasant origin, his early association with landscape painters, his humanitarianism, and his reading of the Bible and Virgil.

2. The second paragraph takes a close look at some aspects of the picture (the women's hands, their position in the foreground, the harvesters above and behind them, the oppressive sky), and the third paragraph makes illuminating comparisons with two other paintings.

3. The last paragraph, like most good concluding paragraphs, while recapitulating the main point (the depiction of ageless labors), enlarges the vision by including references to Millet's younger contemporaries who shared his vision. Notice that this new material does not leave us looking forward to another para-

graph but neatly opens up, or enriches, the matter and then turns it back to Millet. (For additional remarks on introductory and concluding paragraphs, see pp. 107–10.)

SOME KINDS OF ESSAYS

Most of this book will be devoted to writing about what we perceive when we look closely at a work of art, but it is worth noting that other kinds of writing can also help a reader to see (and therefore to understand better) a work of art. For example, one might discuss not a single picture but, say, a motif: Why does the laborer become a prominent subject in nineteenth-century European painting? Or how does the theme of leisure differ between eighteenth-century and nineteenth century painting, that is what classes are depicted, how aware of each other are the figures in a painting, what are the differences in the settings and activities — and why?

Such a discussion might be largely a **sociological study,** and the esthetic qualities of the works of art might be of minor importance. Thus, an analysis of French "Orientalist" paintings — pictures of the Middle East by such artists as Delacroix and Gérôme — might concentrate on the ways in which these paintings depict, not simply the Middle East, but also the European colonialist's view that the Middle East is a place of barbarism and corruption that is badly in need of European law and order and decency. Or, a primarily sociological study might examine the patrons of art in a given period: To what class did they belong, and what kinds of works did they want the artists to produce? Thus, Gary Schwartz, in *Rembrandt: His Life, His Paintings,* says that his intention is to study Rembrandt as "an artistic interpreter of the literary, cultural, and religious ideas of a fairly fixed group of patrons." Similarly, a study emphasizing the social context of art might try to answer the question: Why does portraiture in Italy in the later fifteenth century show an increased interest in capturing individual likenesses?

In *Art News,* January 1971, Linda Nochlin asked a fascinating sociological question: "Why Have There Been No Great Women Artists?" Nochlin rejects the idea that women lack artistic genius, and instead she finds her answer "in the nature of given social institutions." For instance, women did not have access to nude

models (an important part of the training in the academies), and women, though tolerated as amateur painters, were rarely given official commissions. And, of course, women were expected to abandon their careers for love, marriage, and the family. Furthermore, during certain periods, women artists were generally confined to depicting a few subjects. In the age of Napoleon, for example, they usually painted scenes not of heroism but of humble, often sentimental domestic subjects such as a girl mourning the death of a pigeon. A study of this sort recognizes that works of art carry ideas. It recognizes, too, that the person writing about art is not a disembodied or innocent eye, but inevitably is a person with a point of view, whether feminist, Marxist, capitalist, or whatever.

A related kind of art-historical research is concerned with the study of an artist's **biography.** Again, such a study, say of Cézanne's relationship with his father, might deal only marginally with the esthetic qualities of art, though of course, especially if it is psychoanalytic, it might help account for certain motifs in the artist's works. A psychoanalytic study of Winslow Homer argues that his works are related to crises in his life. For instance, *The Life Line* and *The Undertow,* two pictures that show men rescuing women, are said to reveal Homer's love for his mother and his desire to rescue her from death. Again, a writer with an interest in biography might study the degree to which Picasso's style changed as he changed wives or mistresses, or as he changed his literary friends — Apollinaire influencing Picasso's cubism, Cocteau his neoclassicism, and Breton his surrealism.

One highly specialized kind of study is concerned with **iconography** (Greek for "image writing"), that is, with the identification of images with symbolic content or meaning. In Erwin Panofsky's words, iconography is concerned with "conventional subject matter," the iconographer showing us that certain forms are (for example) saints or gods or allegories. An iconographic study might point out that a painting by Rembrandt of a man holding a knife is not properly titled *The Assassin,* as it was once called, since it depicts St. Bartholomew, who, because he was skinned alive with a knife, is regularly depicted with a knife in his hand. (Saints often hold an *attribute,* that is, some object that serves to identify them. St. Peter, for example, holds keys.) But is every image of a man holding a knife St. Bartholomew? Of course not, and if, as in

Rembrandt's painting, the figure wears contemporary clothing and has no halo, skepticism is warranted. Why can't the picture be of an assassin — or of a butcher or a cook or a surgeon? But a specialist in the thought (including the art) of the period might point out that the identification of this figure with St. Bartholomew is reasonable on two grounds. First, the picture, dated 1661, seems to belong to a series of pictures of similar size, showing half-length figures, all painted in 1661, and at least some of these surely depict apostles. For example, the man with another man at his right is Matthew, for if we look closely, we can see that the trace of a wing protrudes from behind the shoulder of the accompanying figure, and a winged man (or angel) is the attribute or symbol of Matthew. In another picture in this series a man leaning on a saw can reasonably be identified as Simon the Zealot, who was martyred by being sawn in half. Second, because the Protestant Dutch were keenly interested in the human ministry of Christ and the apostles, images of the apostles were popular in seventeenth-century Dutch art, and it is not surprising that Rembrandt's apostles look more like solid citizens of his day than like exotic biblical figures. In short, to make the proper identification of an image, one must understand how the image relates to its contemporary context.

Iconology (Greek for "image study") is the interpretation, especially through literary, religious, and philosophical texts, of the image for evidence of the cultural attitudes that produced what can be called the meaning or content of the work. For instance, an image of a man chained to a rock, with an eagle feeding on his liver, can be identified as Prometheus, the Titan who stole fire from the gods and gave it to mortals. Iconology tells us that as early as the fifth century B.C. the Greeks gave this image a particular interpretation: Prometheus gave mortals not merely a natural element, fire, but divine wisdom. That is, the fire was seen as symbolic of a particular quality of the gods. But from reading certain texts we learn that early Christians gave the image a somewhat different content: They saw in Prometheus's gift an image of Christ rescuing mortals from their wretched sinful condition, and in Prometheus's enchainment they saw an image of Christ's crucifixion. Here we might say that the story becomes allegorical, that is, we get a system of equivalents: Prometheus = Christ; mortals lacking fire = sinners; the rock = the cross. The late eighteenth century saw in the image yet a different content: Prometheus was the inspired artist whose cre-

ative imagination is symbolized by heavenly fire. In the nineteenth century, Prometheus often was seen as the alienated artist, the exceptional human being who gives a precious gift to mortals but whose nature condemns him to isolation and suffering.

Similarly, to glance at another image, iconology can teach us the significance of changes in pictures of the Annunciation, in which the angel Gabriel confronts Mary. These changes reveal cultural changes. Early paintings show a majestic Gabriel and a submissive Virgin. Gabriel is crowned and he holds a scepter, the emblem of sovereignty. But from the fifteenth century onward the Virgin is shown as the Queen of the Angels, and Gabriel, kneeling and thus no longer dominant, carries a lily or a scepter tipped with a lily, emblem of the Virgin's purity. In this example, then, iconology — the study of iconography — calls to our attention evidence of a great change in religious belief.

These are highly specialized studies, requiring a good deal of research. For instance, Schwartz's study of Rembrandt in the context of patronage required him to examine seventeenth-century wills, tax regulations, and records of birth, marriage, and burial. Probably your instructor will begin by assigning something rather different, asking you — at least for the first assignment — to get on paper a sense of what you see in a work in front of you. This kind of essay, **formal analysis,** is the subject of the next chapter.

Writing an essay of any kind ought not to be an activity doggedly engaged in to please the instructor; it ought to be a stimulating, if taxing, activity that educates you and your reader. The job is twofold — seeing and saying — but these two finally are inseparable, for if you don't say it effectively, the reader won't see what you have seen, and perhaps you haven't seen it clearly either. What you say, in short, is a sort of device for helping the reader *and yourself* to see clearly.

EXPRESSING OPINIONS

The study of art is not a science, but neither is it the expression of random feelings loosely attached to works of art. You can — must — come up with statements that seem true to the work itself, statements that almost seem self-evident (like Clark's words

about Rembrandt) when the reader of the essay turns to look again at the object.

You have feelings about the object under discussion, and you reveal them not by continually saying "I feel" and "this moves me" but by calling attention to qualities in the object that shape your feelings. Thus, if you are writing about Picasso's *Les Demoiselles d'Avignon,* instead of saying, "My first feeling is one of violence and unrest," it is probably better to call attention (as John Golding does, in *Cubism*) to "the savagery of the two figures at the right-

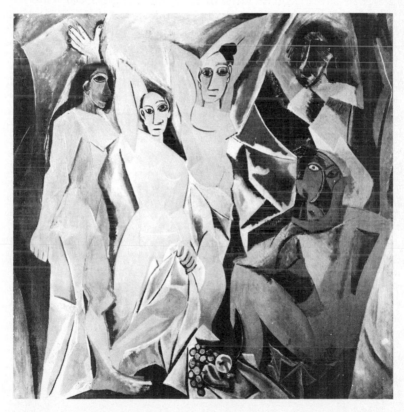

Pablo Picasso. *Les Demoiselles d'Avignon,* 1907. Oil on canvas, 8′ × 7′8″. Collection, The Museum of Modern Art, New York. (Acquired through the Lillie P. Bliss Bequest)

hand side of the painting, which is accentuated by the lack of expression in the faces of the other figures." Golding does this in order to support his assertion that "the first impression made by the *Demoiselles* . . . is one of violence and unrest." The point, then, is not to repress or to disguise one's personal response but to suggest that this response is not eccentric and private. Golding can safely assume that his response is tied to the object, and he can also safely assume that we share his initial response because he cites evidence that pretty much compels us to feel as he does. Here, as in most good criticism, we get what has been called "persuasive description."

Understandably, instructors would rather hear the evidence than hear assertions about the writer's feelings, but to say that a writer does not keep repeating "I feel" is not to say that "I" cannot be used. Nothing is wrong with occasionally using "I," and noticeable avoidances of it — "It is seen that," "this writer," "we," and the like — suggest an offensive sham modesty; still, too much talk of "I" makes a writer sound like an egomaniac.

2
Analysis

ANALYTICAL THINKING:
SEEING AND SAYING

An analysis is, literally, a separating into parts in order
to understand the whole. You might, for example, analyze
Michelangelo's marble statue *David* (p. 16) by considering

> its sources (in the Bible, in Hellenistic sculpture, in Donatello's
> bronze *David,* and in the ideas of the age — e.g., David as a
> civic hero and David as the embodiment of Fortitude)
>
> its material (marble lends itself to certain postures but not to
> others, and marble has an effect — in texture and color — that
> granite or bronze or wood does not have)
>
> its pose (which gives it its outline, its masses, and its enclosed
> spaces or lack of them)
>
> its facial expression
>
> its nudity (a nude Adam is easily understandable, but why a
> nude David?)
>
> its size (here, in this over-life-size figure, man as hero)
>
> its original site

and anything else you think the sculpture consists of — or does not
consist of, for Michelangelo, unlike his predecessor Donatello,
does not include the head of the slain Goliath, and thus Michelan-
gelo's image is not explicitly that of a conquering hero. Or you
might confine your attention to any one of these elements.

Analysis, of course, is not a process used only in talking about
art. It is commonly applied in thinking about almost any complex
matter. Martina Navratilova plays a deadly game of tennis. What

15

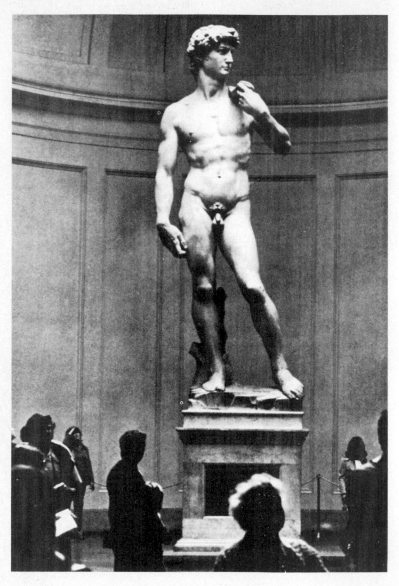

Michelangelo, *David,* 1501–4. Marble, 13′5″. Accademia, Florence.
(Photograph courtesy of H. W. Janson)

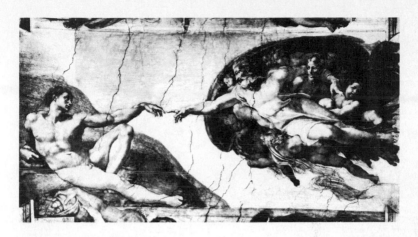

Michelangelo, *The Creation of Adam,* 1508–12. Fresco, 9′2″ × 18′8″.
Sistine Chapel, Vatican City. (The Vatican Museums)

makes it so good? How does her backhand contribute? What does
her serve do to her opponents? The relevance of such questions is
clear. Similarly, it makes sense, if you are writing about art, to try
to see the components of the work.

Here is a very short analysis of one aspect of one of Michel-
angelo's paintings, *The Creation of Adam* (1508–12), on the ceiling
of the Sistine Chapel. The writer's *thesis,* or point that underlies his
analysis, is, first, that the lines of a pattern say something, com-
municate something to the viewer, and, second, that the viewer
does not merely *see* the pattern but experiences it, participates in it.

> The "story" of Michelangelo's *Creation of Adam,* on the ceiling
> of the Sistine Chapel in Rome, is understood by every reader of the
> book of Genesis. But even the story is modified in a way that makes
> it more comprehensible and impressive to the eye. The Creator, in-
> stead of breathing a living soul into the body of clay — a motif not
> easily translatable into an expressive pattern — reaches out toward
> the arm of Adam as though an animating spark, leaping from fin-
> gertip to fingertip, were transmitted from the maker to the creature.
> The bridge of the arm visually connects two separate worlds: the
> self-contained compactness of the mantle that encloses God and is
> given forward motion by the diagonal of his body; and the incom-

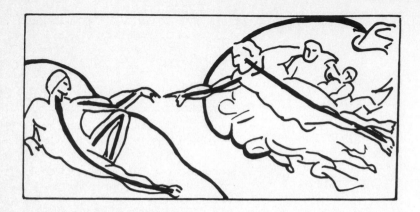

plete, flat slice of the earth, whose passivity is expressed in the back-
ward slant of its contour. There is passivity also in the concave curve
over which the body of Adam is molded. It is lying on the ground
and enabled partly to rise by the attractive power of the approaching
creator. The desire and potential capacity to get up and walk are
indicated as a subordinate theme in the left leg, which also serves as
a support of Adam's arm, unable to maintain itself freely like the
energy-charged arm of God.

Our analysis shows that the ultimate theme of the image, the
idea of creation, is conveyed by what strikes the eye first and con-
tinues to organize the composition as we examine its details. The
structural skeleton reveals the dynamic theme of the story. And since
the pattern of transmitted, life-giving energy is not simply recorded
by the sense of vision but presumably arouses in the mind a corre-
sponding configuration of forces, the observer's reaction is more
than a mere taking cognizance of an external object. The forces that
characterize the meaning of the story come alive in the observer and
produce the kind of stirring participation that distinguishes artistic
experience from the detached acceptance of information.

> Rudolf Arnheim, *Art and Visual Perception,*
> New Version (Berkeley and Los Angeles:
> University of California Press, 1974), pp. 458–60

Notice that Arnheim does not discuss color, or the Renais-
sance background, or the place of the work in its site or in Michel-
angelo's development, though any or all of these are fit topics also.
He has chosen to analyze the effect of only one element, but his

paragraphs *are* an analysis, an attempt to record perceptions and to reflect on them.

SUBJECT MATTER AND CONTENT

Before we go on to analyze some of the ways in which art communicates, we can take a moment to distinguish between the *subject matter* of a work and the *content* or *meaning*. (Later in this chapter, on pp. 52–57, we will see that the content or meaning is expressed through the *style* or *form,* but it is best to postpone discussion of those difficult terms for as long as possible.)

Something has already been said (p. 11) on iconology, the study of artistic images and the cultural thoughts and attitudes that they reflect. For example, two pictures of the same subject matter — the Crucifixion — can express different meanings: One picture can show Christ's painful death (head drooping to one side, eyes closed, brows and mouth contorted, arms pulled into a V by the weight of the body, body twisted into an S shape); the other can show Christ's conquest of death (eyes open, face composed, arms horizontal, body relatively straight and self-possessed). The subject matter in both is the same — the Crucifixion — but the meaning or content is utterly different.

Or, to turn to another genre, if we look at some nineteenth-century landscapes we may see (aided by Barbara Novak's *Nature and Culture: American Landscape and Painting 1825–1875*) that the subject matter of skies streaked with red and yellow embodies a *content* that can be described, at least roughly, as the grandeur of God. Perhaps Paul Klee was trying to turn our attention from subject matter to content when he said, "Art does not reproduce the visible; rather, it makes visible." The content, one might say, is the subject matter transformed or recreated or infused by intellect and feeling with meaning — in short, the content is a meaning made visible. This is what Henri Matisse was getting at when he said that drawing is "not an exercise of particular dexterity but above all a means of expressing intimate feelings and moods."

Even abstract or nonobjective art, one can argue, makes vis-

ible the artist's inner experiences and thus has a subject matter that conveys a meaning. Consider Picasso's words: "There is no abstract art. You must always start with something. Afterward you can remove all traces of reality. There is no danger then, anyway, because the idea of the object will have left an indelible mark. It is what started the artist off, excited his ideas, and stirred up his emotions. Ideas and emotions will in the end be prisoners in his work." This seems entirely reasonable. A bit less reasonable, but still only an exaggeration rather than an utter falsehood, is Vassily Kandinsky's remark: "The impact of an acute triangle on a sphere generates as much emotional impact as the meeting of God and Adam in Michelangelo's *Creation*." In this exaggeration Kandinsky touches on the truth that a painting conveys more than the objects that it represents. Still, lest we go too far in searching for a content in or behind or under the subject matter, we should recall a story. In the 1920s the poet Paul Eluard was eloquently talking to Joan Miró about what Eluard took to be a solar symbol in one of Miró's paintings. After a decent interval Miró replied, "That's not a solar symbol. It is a potato."

Speaking metaphorically, we can say that the meaning or content of a work of art is conveyed in the *language* of the art. For example, a picture with short, choppy, angular lines will "say" something different from a picture with gentle curves, even though the subject matter (let's say a woman sitting at a table) is approximately the same. When Klee spoke of "going for a walk with a line," he had in mind a line's ability (so to speak) to move quickly or slowly, assertively or tentatively. Of course many of the words we use in talking about lines — or shapes or colors — are metaphoric. If, for instance, we say that a line is "agitated" or "nervous" or "tentative" or "bold" we are not implying that the line is literally alive and endowed with feelings. We are really talking about the way in which we perceive the line, or, more precisely, we are setting forth our inference about what the artist intended or in fact produced, but such talk is entirely legitimate.

Are the lines of a drawing thick or thin, broken or unbroken? A soft pencil drawing on pale gray paper will say something different from a pen drawing made with a relatively stiff reed nib on bright white paper; at the very least the medium and the subdued contrast of the one are quieter than those of the other. Similarly, a

painting with a rough surface built up with vigorous or agitated brush strokes will not say the same thing — will not have the same meaning — as a painting with a smooth, polished surface that gives no evidence of the brush. If nothing else, the painting that gives evidence of brush strokes announces the presence of the painter, whereas the polished surface seems to eliminate the painter from the painting. For obvious examples, compare a work by an Action painter of the late 1940s and the 1950s such as Jackson Pollock (the marks on the canvas almost let us see the painter in the *act* of brushing or dribbling or spattering the pigment) with a work by a Pop artist such as Andy Warhol or Robert Indiana. Pop artists tended to favor commonplace images (e.g., Campbell's soup cans) and impersonal media such as the serigraph. Their works call to mind not the individual artist but anonymous commercial art and the machine, and these commercial, mechanical associations are part of the meaning of the works. Such works express what Warhol said in 1968: "The reason I'm painting this way is because I want to be a machine."

ASKING QUESTIONS TO GET ANSWERS

The painter Ad Reinhardt once said that "Looking is not as simple as it looks." What are some of the basic things to look for in trying to acquire an understanding of the languages of art, that is, in trying to understand what a work of art expresses? Matisse has a comment on how all of the parts of a work contribute to the whole: "Expression to my way of thinking does not consist of the passion mirrored upon a human face or betrayed by a violent gesture. The whole arrangement of my picture is expressive. The place occupied by figures or objects, the empty spaces around them, the proportions, everything plays a part."

One can begin a discussion of this complex business of expression in the arts almost anywhere, but let's begin with some basic questions that can be asked of almost any work of art — whether a painting or a drawing or a sculpture or even a building.

What is my first response to the work? (Later you may modify or even reject this response, but begin by trying to study it.)

When and where was the work made? Does it reveal the qualities that your textbook attributes to the culture? (Don't assume that it does; works of art have a way of eluding easy generalizations.) *Where would the work originally have been seen?* Perhaps in a church or a palace, or a bourgeois home, but surely not in a museum or a textbook. For Picasso, "The picture-hook is the ruination of a painting. . . . As soon as [a painting] is bought and hung on a wall, it takes on quite a different significance, and the painting is done for."

What purpose did the work serve? To stimulate devotion? To enhance family pride? To teach? To delight? Does the work present a likeness, or express a feeling, or illustrate a mystery?

In what condition has the work survived? Is it exactly as it left the artist's hands, or has it been damaged, repaired, or in some way altered? What evidence of change do I see?

*What is the **title**? Does it help to illuminate the work?* Sometimes it is useful to ask yourself, What would I call the work? Picasso called one of his early self-portraits *Yo Picasso,* i.e., "I Picasso," rather than, say, *Portrait of the Artist,* and indeed his title goes well with the depicted self-confidence. Charles Demuth called his picture of a grain elevator in his hometown of Lancaster, Pennsylvania, *My Egypt,* a title that nicely evokes both the grandeur of the object (the silo shafts and their cap resemble an Egyptian temple) and a sense of irony (Demuth, longing to be in New York or Paris, was "in exile" in Lancaster). But note that many titles were not given to the work by the artist, and some are positively misleading. Rembrandt's *Night Watch* was given that name at the end of the eighteenth century, when the painting had darkened; it is really a daytime scene. And we have already noticed, on page 3, that one's response to a Rembrandt painting may differ, depending on whether it is titled *Self-Portrait with Saskia* or *The Prodigal Son.* Finally, one should recall that some painters have changed the titles of their works; Edvard Munch first called a picture *Woman Kissing the Neck of a Man,* but later he accepted as its title the suggestion of a friend, *The Vampire.*

If you ask yourself such questions, answers (at least tentative answers) will come to mind. In short, you will have something to

say, something to write when called on to write. Here are some additional questions to ask, first on drawing and painting, then on sculpture, architecture, and photography.

Drawings and Paintings

What is the subject matter? What (if anything) is happening?

Baudelaire said that a **portrait** is "a model complicated by an artist." A portrait, one can say, is not simply a representation; it is also a presentation. In a given portrait, how much of the figure does the artist show, and how much of the available space does the artist cause the figure to occupy? What effects are thus gained? What do the clothes, furnishings, accessories (swords, dogs, clocks, and so forth), background, and angle of the head or the posture of the head and body (as well as the facial expression, of course) contribute to our sense of the personality (intense, or cool, or inviting, or whatever) of the figure portrayed? Does a given artist present a strong sense of a social class (as Frans Hals does in his portraits), or a strong sense of an independent inner life (as Rembrandt does)? Is the view frontal, three-quarter, or profile? (It is usually held that a three-quarter view affords the artist the greatest opportunity to reveal personality.) Is the figure related to the viewer, perhaps by a glance or gesture? If frontal, does it seem to face us in a godlike way, seeing all? If three-quarter, does it suggest motion? If profile, is the emphasis decorative, or psychological? If the picture is a double portrait, does the artist reveal what it is that ties the two figures together?

It is sometimes said that every portrait is a self-portrait; does this portrait seem to reveal the artist in some way? Does the portrait, in fact, reveal anything at all? Looking at John Singer Sargent's portrait entitled *General Sir Ian Hamilton,* the critic Roger Fry said, "I cannot see the man for the likeness." Sargent, by the way, said that he saw an animal in every sitter.

(For a student's discussion of two portraits by Copley, see page 73. For a professional art historian's discussion of Van Dyck's portrait of Charles I, see page 103.)

If the picture is a **still life,** does it suggest opulence, or does it suggest humble domesticity and the benefits of moderation?

Does it imply transience, perhaps by a clock or a burnt-out candle, or even merely by the perishable nature of the objects (food, flowers) displayed? If the picture shows a piece of bread and a glass of wine flanking a vase of flowers, can the bread and wine perhaps be eucharistic symbols, the picture as a whole representing life-everlasting achieved through grace? Is there a contrast between the inertness and sprawl of a dead animal and its vibrant color or texture? Does the work perhaps even suggest, as some of Chardin's dead rabbits do, something close to a reminder of the Crucifixion? Or is all of this allegorizing irrelevant?

In a **landscape,** what is the relation between human beings and nature? Are the figures at ease in nature, or are they dwarfed by it? Are they earthbound, beneath the horizon, or (because the viewpoint is low) do they stand out against the horizon and perhaps seem in touch with the heavens, or at least with open air? If there are woods, are these woods threatening or are they an inviting place of refuge? Exactly what makes these woods either threatening or inviting? If there is a clearing, is the clearing a vulnerable place or is it a place of refuge from ominous woods? Do the natural objects in the landscape somehow reflect the emotions of the figures? If the landscape, as in many seventeenth-century Dutch paintings, seems highly realistic, is it also in some ways expressive of spiritual forces? Does the painting emphasize the play of light and the insubstantiality of objects in beautiful spaces, as is usual in the work of Claude Lorrain, Turner, and Monet, or does it emphasize the volume — of hills and trees for example — as is usual in the work of Poussin and van Gogh?

Are the **contour lines** (outlines of shapes) strong and hard, or are they irregular, indistinct, fusing the objects or figures with the surrounding space?

What does the **medium** (the substance on which the artist acted) contribute? If a drawing has been made with a wet medium (e.g., ink applied with a pen, or washes applied with a brush), what has the degree of absorbency of the paper contributed? Are the lines of uniform width, or do they sometimes swell and sometimes diminish, either abruptly or gradually? (Quills and steel pens are more flexible than reed pens.) If the drawing has been made with

a dry medium (e.g., silverpoint, charcoal, chalk, or pencil), what has the smoothness or roughness of the paper contributed? (When crayon is rubbed over textured paper, bits of paper show through, suffusing the dark with light, giving vibrancy.) If the work is a painting, is it in tempera (pigment dissolved in egg, the chief medium of European painting into the later fifteenth century), which usually has a somewhat flat, dry appearance? Because the brush strokes do not fuse, tempera tends to produce forms with sharp edges — or, we might say, because it emphasizes contours it tends to produce colored drawings. Or is the painting done with oil paint, which (because the brush strokes fuse) is better suited than tempera to give an effect of muted light and blurred edges? Thin layers of translucent colored oil glazes can be applied so that light passing through these layers reflects from the opaque ground colors, producing a soft radiant effect; or oil paint can be put on heavily *(impasto),* giving a rich, juicy appearance. Impasto can be applied so thickly that it stands out from the surface and catches the light. Oil paint is thus sometimes considered more painterly than tempera, or, to reverse the matter, tempera is sometimes considered to lend itself to a more linear treatment.

Is the **color** (if any) imitative of appearances, or expressive, or both? (Why did Picasso use white, grays, and black for *Guernica,* when in fact the Spaniards bombarded the Basque town on a sunny day?)

Vincent van Gogh, speaking of his own work, said he sought "to express the feelings of two lovers by a marriage of two complementary colors, their mixture and their oppositions, the mysterious vibrations of tones in each other's proximity. . . . To express the thought behind a brow by the radiance of a bright tone against a dark ground."

Caution: It is often said that *warm colors* (red, yellow, orange) produce a sense of excitement, whereas *cool colors* (blue, green) have a calming effect, but experiments have proved inconclusive; the response to color — despite clichés about seeing red or feeling blue — is highly personal, highly cultural, highly varied. Still, a few things can be said, or at least a few terms can be defined. *Hue* gives the color its name — red, orange, yellow, green, blue, violet. *Value* (also called *lightness* or *darkness, brightness* or *intensity*) refers to rel-

ative lightness or darkness of a hue. When white is added, the value becomes "higher"; when black is added, the value becomes "lower." The highest value is white; the lowest is black. *Saturation* (also called *hue intensity*) is the strength of a hue — one red is redder than another; one yellow is paler than another. A vivid hue is of high saturation; a pale hue is of low saturation. But note that much in a color's appearance depends on context. Juxtaposed against green, red will appear redder than if juxtaposed against orange. A gray patch surrounded by white will seem darker than gray surrounded by black.

When we are armed with these terms, we can say, for example, that in his South Seas paintings Paul Gauguin used *complementary colors* (orange and blue, yellow and violet, red and green, i.e., hues that when mixed absorb almost all white light, producing a blackish hue) at their highest values, but it is harder to say what this adds up to. (Gauguin himself said that his use of complementary colors was "analogous to Oriental chants sung in a shrill voice," but one may question whether the analogy is helpful.) And for several reasons our nerve may fail when we try to talk about the effect of color: Light and moisture cause some pigments to change over the years; the colors of a medieval altarpiece illuminated by flickering candlelight or by light entering from the yellowish translucent (not transparent) glass or colored glass of a church cannot have been perceived as the colors that we perceive in a museum, and, similarly, a painting by van Gogh done in bright daylight cannot have looked to van Gogh as it looks to us on a museum wall. The moral? Be cautious in talking about the effect of color.

What is the effect of **light** in the picture? Does it produce sharp contrasts, brightly illuminating some parts and throwing others into darkness, or does it, by means of gentle gradations, unify most or all of the parts? Does the light seem theatrical or natural, disturbing or comforting? Is light used to create symbolic highlights?

Do the objects or figures share the **space** evenly, or does one overpower another, taking most of the space or the light? What is the focus of the composition? The **composition** — the ordering of the parts into a whole by line, color, and shape — is sometimes

grasped at an initial glance and at other times only after close study. Is the composition symmetrical (and perhaps therefore monumental, or quiet, or rigid and oppressive)? Is it diagonally recessive (and perhaps therefore dramatic or even melodramatic)?

Are figures harmoniously related, perhaps by a similar stance or shared action, or are they opposed, perhaps by diagonals thrusting at each other? Speaking generally, **diagonals** may suggest motion or animation or instability, except when they form a triangle resting on its base, which is a highly stable form. **Horizontal lines** suggest tranquility or stability — think of plains, or of reclining figures. **Vertical lines** —tree trunks thrusting straight up, or people standing, or upright lances as in Velázquez's *Surrender of Breda* — may suggest a more vigorous stability. **Circular lines** are often associated with motion and sometimes — perhaps especially by men — with the female body and with fertility. It is even likely that Picasso's *Still-Life on a Pedestal Table,* with its rounded forms, is, as he is reported to have called it, a "clandestine" portrait of one of his mistresses. These simple formulas, however, must be applied cautiously, for they are not always appropriate. Probably it is fair to say, nevertheless, that when a *context* is so established, for instance by means of the title of a picture, these lines may be perceived to bear these suggestions if the suggestions are appropriate.

Does the artist convey **depth,** that is, **recession in space?** If so, how? If not, why not? (Sometimes space is flattened — for example, to convey a sense of otherworldliness or eternity.) Among the chief ways of indicating depth are

1. *overlapping* (the nearer object overlaps the farther);
2. *foreshortening* (as in the recruiting poster, *I Want You,* where Uncle Sam's index finger, pointing at the viewer, is represented chiefly by its tip, and, indeed, the forearm is represented chiefly by a cuff and an elbow);
3. *contour hatching,* that is, lines or brush strokes that follow the shape of the object depicted, as though a net were placed tightly over the object;
4. *shading or modeling,* that is, representation of body shadows;
5. representation of *cast shadows;*

6. *relative position from the ground line* (objects higher in the picture are conceived of as further away than those lower);
7. *perspective* (parallel lines seem to converge in the distance, and a distant object will appear smaller than a near object of the same size.★ Some cultures, however, use a principle of *hierarchic scale*. In such a system a king, for instance, is depicted as bigger than a slave not because he is nearer but because he is more important; similarly, the Virgin in a nativity scene may be larger than the shepherds even though she is behind them);
8. *aerial* — or *atmospheric* — *perspective* (remote objects may seem — depending on the atmospheric conditions — slightly more bluish than similar near objects, and they may appear less intense in color and less sharply defined than nearer objects. Note that aerial perspective does *not* have anything to do with a bird's-eye view). Does the picture present a series of planes, each parallel to the picture surface, or does it, through some of the means just enumerated, present an uninterrupted extension of one plane into depth?

What is the effect of the **shape** and **size** of the work? Because, for example, most still lifes use a horizontal format, a vertical still life may seem relatively monumental. Note too that a larger-than-life portrait will produce an effect (probably it will seem heroic) different from one ten inches high. If you are working from a reproduction be sure, therefore, to ascertain the size of the original.

What is the **scale,** that is, the relative size? A face that fills a canvas will produce a different effect from a face of the same size that is drawn on a much larger canvas; probably the former will seem more expansive or more energetic, even more aggressive.

★In the Renaissance, perspective was used chiefly to create a coherent space and to locate objects within that space, but later artists have sometimes made perspective expressive. Giorgio de Chirico, for example, often gives a distorted perspective that unnerves the viewer. Or consider van Gogh's *Bedroom at Arles*. Although van Gogh said that the picture conveyed "rest," viewers find the swift recession disturbing. Indeed, the perspective in this picture is impossible: If one continues the diagonal of the right-hand wall by extending the dark line at the base, one sees that the bed's rear right foot would be jammed into the wall.

Sculpture

For what **purpose** was this object made? To edify the faithful? To commemorate heroism? The purpose of the Vietnam Veterans Memorial, dedicated in 1982, was radically changed in 1984, as both the admirers and the foes of the original memorial admit, by the addition of an eight-foot sculpture of three soldiers and a fifty-foot flagpole. Maya Lin's original design called only for a pair of two-hundred-foot black granite walls that join to make a wide V, embracing a gently sloping plot of ground. On the walls, which rise from ground level to a height of ten feet at the vertex, are inscribed the names of the 57,939 Americans who died in Vietnam. Opponents of this design argued that it commemorated the dead but ignored the veterans who survived, and was silent about the justice of the cause. The monument said nothing about heroism, these detractors claimed, in contrast to the Marine Corps Memorial

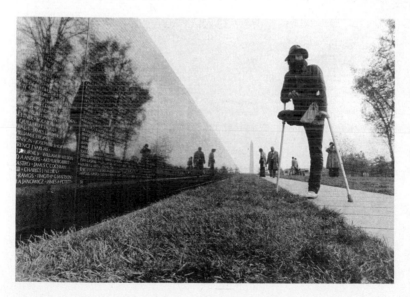

Maya Lin, The Vietnam Veterans Memorial, 1982. UPI/Bettmann Newsphotos

across the Potomac River, which consists of a statue of marines raising the American flag on Iwo Jima. (One might reply that the Vietnam Memorial, which records the names of those who died, focuses on individuals, whereas the Marine Corps Memorial focuses on the collective heroism of one branch of the armed services.) The politically conservative *National Review* argued in an editorial that Lin's memorial implied an antiwar stance in its black color and in its V-shaped walls ("the antiwar signal, the V protest made with the fingers"). One respondent wrote that the V should be perceived as "the chevron of the PFC who bore the brunt in the fighting of the war." Other defenders of the original design argued that the site itself — "sacred ground between the Washington Monument and the Lincoln Memorial" — adequately testified to the cause. The Federal Fine Arts Commission, which has authority over the design and location of federal monuments, came up with a compromise: The sculpture of the three soldiers and the flagpole were added to the original design, but they were placed near an entrance to the memorial, whereas their proponents wanted the soldiers to form a centerpiece within the triangular plot of land embraced by the walls, and the flagpole to stand at the apex of the V. Advocates of the original design remain unhappy, arguing that it has become a mere backdrop to the figurative sculpture, and that the new composite monument replaces dignity, poignancy, and a symbol of loss with simplistic patriotism or, more bluntly, with a symbol of war. In any case, one cannot doubt that the two factions envisioned different purposes, and the purposes shaped the memorial that each proposed.

What are the **sources** or previous models? How does this piece differ from them?

What does the **pose** imply? Effort? Rest? Arrested motion? Authority? In the Lincoln Memorial, Lincoln sits; in the Jefferson Memorial, Jefferson stands, one foot slightly advanced. Lincoln's pose, as well as his face, suggests weariness, while Jefferson's pose, as well as his faintly smiling face, suggests confidence and action. How relevant to a given sculpture is Rodin's comment that "The body always expresses the spirit for which it is the shell"? If the work is a bust, does it imply a stance or does it seem to float freely?

How forceful or how tenuous is the expression of three-dimensionality?

Are certain bodily features or forms distorted? If so, why? (In most African equestrian sculpture, the rider — usually a chief or an ancestor — dwarfs the horse, in order to indicate the rider's high status.)

To what extent is the **drapery** independent of the body? Does it express or diminish the **volumes** (enclosed spaces, e.g., breasts, knees) that it covers? Does it draw attention to specific points of focus, such as the head or hands? Does it indicate bodily motion or does it provide an independent harmony? What does it contribute to whatever the work expresses? If the piece is a wall or niche sculpture, does the pattern of the drapery help to integrate the work into the facade of the architecture?

What do the **medium** *and* the **techniques** by which it was shaped contribute? Clay is different from stone or wood, and stone or wood can be rough or they can be polished. Would the statue of Chefren (also called Khafre, Egyptian, third millenium B.C., p. 33) have the same effect if it were in clay instead of in highly polished diorite? Can one imagine Daniel Chester French's marble statue of Lincoln, in the Lincoln Memorial, done in stainless steel? What are the associations of the material, and, even more important, what is the effect of the tactile qualities, for example, polished wood versus terra-cotta? Note that the tactile qualities result not only from the medium but also from the **facture,** that is, the process of working on the medium with certain tools. An archaic Greek *kouros* ("youth") may have a soft, warm look not only because of the porous marble but because of traces left, even after the surface was smoothed with abrasives, of the sculptor's bronze punches and (probably) chisels.

Consider especially the distinction between **carving** and **modeling,** that is, between cutting away, to release the figure from the stone or wood, and, on the other hand, building up, to create the figure out of lumps of clay or wax. Rodin's *Walking Man* (p. 106), built up by modeling clay and then cast in bronze, recalls in every square inch of the light-catching surface a sense of the energy that is expressed by the figure. Can one imagine Michelangelo's

David (p. 16), carved in marble, with a similar surface? Even assuming that a chisel could in fact imitate the effects of modeling, would the surface thus produced catch the light as Rodin's does? And would such a surface suit the pose and facial expression of *David?* Similarly, *King Chefren* was carved; the sculptor, so to speak, cut away from the block everything that did not look like Chefren, whereas *Mercury* (p. 34) was modeled — built up — in clay or wax, and then cast in bronze. The massiveness or stability of *King Chefren* partakes of the solidity of stone, whereas the elegant motion of *Mercury* suggests the pliability of clay, wax, and bronze.

What kinds of volumes are we looking at? Geometric (e.g., cubical, spherical) or irregular? Is the **silhouette** (outline) open or closed? (In Michelangelo's *David,* David's right side is said to be closed because his arm is extended downward and inward; his left side is said to be open because the upper arm moves outward and the lower arm is elevated toward the shoulder. Still, although the form of *David* is relatively closed, the open spaces — especially the space between the legs — emphasize the potential expansion or motion of the figure.) What does the unpierced, thoroughly closed form of *King Chefren,* in contrast to the open form of Giovanni da Bologna's *Mercury,* imply about the subject?

What is the effect of **color,** either of the material or of paint? Is color used for realism or for symbolism? Why, for example, in the tomb of Urban VIII, did Giovanni Bernini use bronze for the sarcophagus (coffin), the pope, and Death, but white marble for the figures of Charity and Justice? The whiteness of classical sculpture is usually regarded as suggesting idealized form (though in fact the Greeks tinted the stone and painted in the eyes), but what is the effect of the whiteness of George Segal's plaster casts (p. 35) of ordinary figures in ordinary situations? Blankness?

What is the **size?** *King Chefren* and *David* are larger than life, *Mercury* (sixty-nine inches to the tip of his extended finger) somewhat smaller than life. What does the size contribute to the meaning or effect?

What was the original **site** or physical context (e.g., a pediment, a niche, or a public square)?

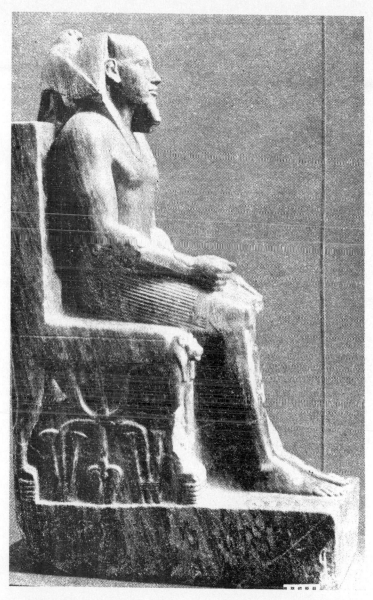

Egyptian, *King Chefren,* ca. 2500 B.C. Diorite, 5'6". Egyptian Museum, Cairo. (Hirmer Fotoarchiv, Hirmer Verlag, München)

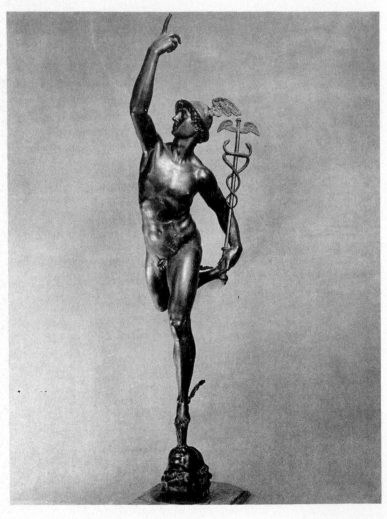

Giovanni da Bologna. *Mercury*. 1580. Bronze, 69″. National Museum, Florence. (Alinari/Art Resource)

George Segal. *The Bus Riders*. 1964. Plaster, metal, and vinyl, 69 × 40 × 76″. Hirshhorn Museum and Sculpture Garden, Smithsonian Institution, Washington, D.C. (Gift of Joseph H. Hirshhorn, 1966)

Is the **base** a part of the sculpture (e.g., rocks, or a tree trunk that helps to support the figure), and, if so, is it expressive as well as functional? George Grey Barnard's *Lincoln — the Man,* a bronze figure in a park in Cincinnati, stands not on the tall classical pedestal commonly used for public monuments but on a low boulder — a real one, not a bronze copy — emphasizing Lincoln's accessi-

bility, his down-to-earthness. Almost at the other extreme, the flying *Mercury* (p. 34) stands tiptoe on a gust of wind, and at the very extreme, Marino Marini's *Juggler* is suspended above the base, emphasizing the subject's airy skill. Compare, too, the implications in the uneven base of Rodin's *Walking Man* (p. 106) with the implications (echoed in the throne and also in the figure) of the base of *King Chefren*. Finally, the pedestal of a statue of Lenin, in a railroad station in Leningrad, is an armored car carved out of stone.

What is expressed through the representation? What, for instance, does the highly ordered, symmetrical form of *King Chefren* suggest about the man? If the sculpture is a head, to what extent is it a portrait, a face revealing a particular appearance and personality at a moment in time? What is the relationship of naturalism to abstraction? If the sculpture represents a deity, what ideas of divinity are expressed? If a human being as a deity (e.g., Alexander the Great as Herakles, or King Chefren as the son of an Egyptian deity), how are the two qualities portrayed?

Where is the best place (or where are the best places) to stand in order to experience the work? How close do you want to get? Why? What effect on you does the size of the piece have?

While we are thinking about sculpture, it is appropriate to speak a word of caution concerning photographs of sculpture. Photographs, of course, are an enormous aid; we can see details of a work that, even if we were in its presence, might be invisible because the work is high above us on a wall or because it is shrouded in darkness. But one must remember, first, that because a photograph is two-dimensional, it can give little sense of a sculpture in the round; second, that color is omitted or falsified, and distinctive textures are obliterated; third, that the photographer's lighting may be misleading, playing up details that are meant to be subordinate or unduly emphasizing some volumes; fourth, that a photograph may not take account of the angle from which the work was supposed to be seen, as when we look at a photograph of Michelangelo's *Moses,* taken straight-on, though the work was supposed to be above the viewer; finally, that we lose the sense of scale, seeing Michelangelo's *David* (about thirteen feet tall) as no bigger than a toy soldier, unless, as in the unusual photograph on page 16, human viewers are also included.

Architecture

The Roman architect Vitruvius suggested that buildings can be judged according to their *utilitas, firmitas,* and *venustas,* that is, according to their fitness for their purpose, their structural soundness, and their beauty; or, in Richard Krautheimer's version, their function, structure, and design. Much (though not all) of what follows is an amplification of these three topics.

What is the **purpose** *of the building?* Is this its original purpose? If not, what was it originally intended for?

Does the building appear today as it did when constructed? Has it been added to, renovated, restored, or otherwise changed in form?

What does the building say? "All architecture," wrote John Ruskin, "proposes an effect on the human mind, not merely a service to the human frame." One can distinguish between function as housing and function as getting across the patron's message. A nineteenth-century bank said, by means of its bulk, its bronze doors, and its barred windows, that your money was safe; and it also said, since it had the facade of a Greek temple, that money was holy. A modern bank, full of glass and color, is more likely to say that money is fun. Some older libraries look like Romanesque churches, and the massive J. Edgar Hoover FBI building in Washington looks like — well, like the FBI. What, then, are the architectural traditions behind the building that contribute to the building's expressiveness? The Boston City Hall (p. 42), for all its modernity and (in its lower part) energetic vitality, is tied together in its upper stories by forceful bands of windows, similar in their effect to a classical building with columns.

Here is how Eugene J. Johnson sees (or hears) Mies van der Rohe's Seagram Building (1954–57):

> Austere, impersonal, and lavishly bronzed, it sums up the power, personality, and wealth of the modern corporation, whose public philanthropy is symbolized by the piazza in front, with its paired fountains — private land donated to the urban populace. If the piazza and twin fountains call to mind the Palazzo Farnese in Rome, so be it, particularly when one looks out from the Seagram lobby across an open space to the Renaissance-revival facade of McKim, Mead

and White's Racquet Club which quotes the garden facade of Palazzo Farnese! Mies set up a brilliant conversation between two classicizing buildings, bringing the nineteenth and twentieth centuries together without compromise on either part. Mies was in many ways *the* great classicist of this century. One might say that one of his major successes lay in fusing the principles of the great classical tradition of Western architecture with the raw technology of the modern age.
 Eugene J. Johnson, "United States of America," in *International Handbook of Contemporary Developments in Architecture,* ed. Warren Sanderson (Westport, Conn.: 1981), p. 506

Notice, by the way, how Johnson fuses *description* (for instance, "lavishly bronzed") with interpretive *analysis* (he sees in the bronze the suggestion of corporate power). Notice, too, how he connects the building with history (the debt of the piazza and twin fountains to the Palazzo Farnese), and how he connects it with its site (the "conversation" with a nearby building).

What is the function of **ornament,** or of any **architectural statuary** in or on or near the building? To emphasize structure? To embellish a surface? To conceal the joins of a surface?

Do the forms and materials of the building relate to its neighborhood? What does the building contribute to the **site?** What does the site contribute to the building? How big is the building in relation to the neighborhood, and in relation to human beings, i.e., what is the **scale?** The Cambridge City Hall (1899; p. 41), atop a slope above the street, crowns the site and announces — especially because it is in a Romanesque style — that it is a bastion of order, even of piety, giving moral significance to the neighborhood below. The Boston City Hall (1965), its lower part in brick, rises out of a brick plaza (p. 42) — the plaza flows into spaces between the concrete pillars that support the building — and seem to invite the crowds from the neighboring shops, outdoor cafés, and marketplace to come in for a look at government of the people by the people, and yet at the same time the building announces its importance.

*Does form follow **function?*** For better or for worse? For example, does the function of a room determine its shape? Are there rooms with geometric shapes irrelevant to their purposes? Louis Sullivan said, "Form ever follows function," but Philip Johnson replied, "Forms always follow forms and not function." Is the form

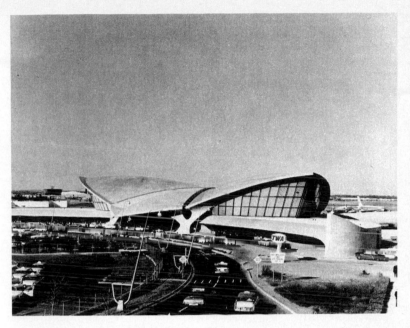

Eero Saarinen, Trans World Airlines Terminal, 1956–62. John F. Kennedy Airport.

symbolic, as it is, for instance, in Eero Saarinen's Trans World Airlines Terminal at Kennedy Airport, where the soaring roof suggests flight?

What is the **structural system?** What **materials** are used in the structure? How do the materials contribute to the building's purpose and statement? The idea that marble confers prestige dies hard: the Sam Rayburn House Office Building in Washington, D.C., is clad in marble veneer (costing many millions of dollars) because marble is thought to confer dignity. On the other hand, brick often suggests warmth or unpretentiousness and handcraftsmanship. Do the exterior walls seem hard or soft, cold or warm? Is the sense of hardness or coldness appropriate? (Don't simply assume that metal must look cold.) Does the material in the interior have affinities with that of the exterior? If so, for better or for worse? (Our experience of an interior brick wall may be very different from our experience of an exterior brick wall.)

Does the exterior stand as a massive sculpture, masking the spaces and the activities within, or does it express them? The exterior of the Boston City Hall emphatically announces that the building harbors a variety of activities; in addition to containing offices it contains conference rooms, meeting halls, an exhibition gallery, a reference library, and other facilities. Are the spaces continuous? Or are they static, each volume capped with its own roof?

Does the interior arrangement of spaces say something — for example, is the mayor's office in the city hall on the top floor, indicating that he is above such humdrum activities as dog licensing, which is on the first floor?

In a given room, *what is the function of the walls?* To support the ceiling or the roof? To afford privacy and protection from weather? To provide a surface on which to hang shelves, blackboards, pictures? If glass, to provide a view in — or out?

What is the effect of the floor (wood, tile, brick, marble, carpet)? Notice especially the effect if you move from a room floored with one material (say, wood) to another (say, carpet). Thus, one writer on Le Corbusier's Villa Savoye points out that "The floor of the ramp is finished in paving laid on a diagonal to reinforce the sense of movement in contrast to the orthogonal details of analogous flagstones on the main terrace."

Is the building inviting? The architect Louis Kahn said, "A building should be a . . . stable and *harboring* thing. If you can now [with structural steel] put columns as much as 100 feet apart you may lose more than you gain because the sense of enclosed space disappears." Is the public invited? The Cambridge City Hall has one public entrance, approached by a flight of steps; the Boston City Hall, its lower floor paved with the brick of the plaza, has many entrances, at ground level. What are the implications in this difference?

"There is no excellent Beauty that hath not some strangeness in the proportion." Thus Francis Bacon, in the early seventeenth century. Does the building evoke and then satisfy a sense of curiosity?

What is the role of **color?** To clarify form? To give sensuous pleasure? To symbolize meaning? Much of the criticism of the Vietnam Veterans Memorial centered on the color of the stone walls.

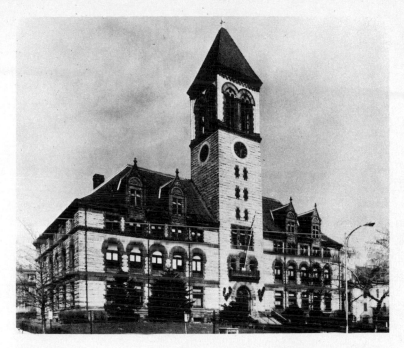

Cambridge City Hall, 1889. Photograph by G. M. Cushing. In *Study of Architectural History in Cambridge, Report Two: Mid-Cambridge* (Cambridge Historical Commission, 1967), p. 44.

One critic, asserting that "black is the universal color of shame [and] sorrow," called for a white memorial.

What part does the changing **daylight** play in the appearance of the exterior of the building? Does the interior make interesting use of natural light? And how light is the interior? (The Lincoln Memorial, open only at the front, is somber within, but the Jefferson Memorial, admitting light from all sides, is airy and suggestive of Jefferson's rational — sunny, we might say — view of life.)

A few words about the organization of an essay on a building may be useful. Much will depend on your purpose, and on the building, but consider the possibility of using one of these three methods of organization:

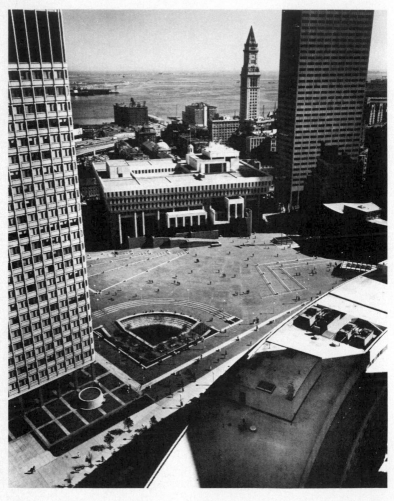

City Hall Plaza Center, 1968. Photograph by Cervin Robinson. In *Architecture Boston* (Boston Society of Architects, 1976), p. 6.

1. You might discuss, in this order, *utilitas, firmitas,* and *venustas,* i.e., function, structure, and design (see p. 37).

2. You might begin with a view of the building as seen at a considerable distance, then at a closer view, and then go on to work from the ground up, since the building supports itself this way.

3. You might take, in this order, these topics:
 a. the materials (smooth or rough, light or dark, etc.).
 b. the general form, perceived as one walks around the building. (Are the shapes square, rectangular, or circular, or what? Are they simple or complex?)
 c. the facades, beginning with the entrance. (Is the entrance dominant or recessive? How is each facade organized? Is there variety or regularity among the parts?)
 d. the relation to the site, including materials and scale.

Photography

First, a few prefatory words. No one today, we can hope, believes that photography is so mechanical a business that a photograph cannot be a work of art. This now discredited view was fostered, ironically, by Kodak: "You press the button, we do the rest." But let's begin with a different simplification, and divide photographers into two schools, **pictorialists** and **reporters.** In the early days of photography, especially in the late nineteenth century, some photographers — we are calling them pictorialists — were not content simply to report images of the world around them. They posed their subjects into compositions resembling those of the Old Masters, and used "Rembrandt lighting," that is, a high side light. Or they photographed moonlit lakes, or rural subjects, watching out for Corot's landscapes and for Millet's peasants laboring in the fields. (The influence went both ways: Corot in the late 1840s seems to have imitated the daguerreotype, whose images of trees are rather blurry or gauzy because of the motion of the leaves during the long exposure.) Moreover, the pictorialists reworked their pictures much as a painter might: They retouched, and they underdeveloped or overdeveloped the negative to produce a desired effect.

Although the most obvious pictorialists are those who, using a soft focus and printing on warm, matte paper, are influenced by mid-nineteenth-century painters and by the Impressionists, many later and utterly different photographs are also pictorial, drawing on the works of later schools of painting. For example, between 1915 and 1930 we get photographs influenced by Cubism, such as Paul Strand's picture of a porch, taken with a tilted camera. Similarly, "abstract" photographs — say, a closeup of a toadstool crossed by a blade of grass, or a detail of a stairway, both of which may appear as almost meaningless patterns of lines and dark and light shapes — are, we can see with hindsight, strongly influenced by the art of their day. The influence of Jean Arp's reliefs and collages, made around the time of World War I, and of Constantin Brancusi's sculpture, is evident ten or fifteen years later in Edward Weston's photographs of a sharply defined, rhythmically shaped object — a green pepper, or a curled-up nude — in a shallow space. Not surprisingly, the abstract photographers tended to use a sharp focus, and they printed their pictures not on matte paper but on cold, hard paper. It is worth noting, too, that some painters, such as Ben Shahn and Charles Sheeler, were also photographers. A photograph by Sheeler, of a cactus with big flat leaves standing on a cylinder in a corner, is virtually identical with one of his paintings; the photograph is no less indebted than the painting to the collages and constructions of Cubist-influenced painters and sculptors, for both images seem almost to have been assembled out of cardboard. And, of course, Sheeler's fondness for monochromatic paintings whose surfaces scarcely seem painterly reveals his frequent reliance, in his paintings, on photographs of his subjects.

Now let's turn to the reporters, the "straight" photographers, the supposedly objective people who give us the stuff of ordinary life, unposed. We seem to be turning from Beauty to Truth, or (if one wants to say that all art communicates truth) from Ideal Truth to the Truth of the Moment. But, it is evident, a photograph does not have to look like an Impressionist painting or a Rembrandt portrait or a Millet genre scene to be called pictorial. A scene of a woman at work in a mill may at first glance appear to be simply a document, a report valuable for the message that it records rather than for its inherent beauty; yet it, too, if it holds us, probably does so largely by its form. Even a newspaper photograph or an ama-

teur's snapshot does not in fact record the object as it really is. It records what you would see if you had only one eye and stood at a particular place at a particular time of day, and if what you saw was printed on a particular kind of paper. To take the most obvious points of mind over mechanism: The photographer selects the subject, the time at which to photograph it (hence the lighting), and the composition, for in taking a photograph one backs up a little, shifts to the left a bit, bends one's legs, waits for the right moment, and so forth. As Antonioni said, "Every camera position represents a moral decision." Granted, "pictorial" photographs are more obviously personal or subjective than are the photographs of reporters, but no photograph taken by a human being can be utterly "objective." Most of the reporters, then, can say with the photographer Minor White, "I don't take pictures, I make them."

Many of the questions on drawing and painting (pp. 23–28) — for example, those on line (edges may be hard or soft), composition, and even color — can be usefully asked of photographs too. Here, however, are a few additional questions.

Does the picture yield all that it has to offer in a glance? Or does the picture sustain and perhaps increase its initial appeal with repeated viewings? Why? Because of the composition, or interesting forms, especially of light and dark? (More about composition in a moment.) Symbolism? Detail (e.g., a face that, whatever its character, is a fascinating map)? Revelation of character, not only through the face but through posture, gesture, and setting (including the angle of vision and the lighting)? Anecdote (or narrative)? Irony, or humor?

Does the photograph capture what Henri Cartier-Bresson calls the **"decisive moment"**? The term alludes not only to an action at its peak but also to the moment when all elements in the composition come together to reveal a formal — usually geometric — beauty. Cartier-Bresson writes, "I have a passion for geometry. My greatest joy is the surprise of facing a beautiful organization of forms." On the other hand, one can find pictures that appeal not because they have the order of geometry but, so to speak, the messy order of life.

Does the **angle of vision** (eye level, or slightly or greatly above or below eye level) say something?

Henri Cartier-Bresson, *Matisse,* 1944. (Magnum)

Does **light** give meaning to the subject. Does light reveal a new aspect of a commonplace subject?

Is the **focus** expressive? Certain parts of the picture may be out of focus, to concentrate a viewer's attention on the focused parts, or to convey, perhaps, a dreamlike quality. If movement is blurred, is the blurring effective?

Is the choice of **print-size** expressive? The print of a photograph may be one inch square, or it may cover a wall.

What **process** was used? The differences among photographic processes can be very great. For instance, albumen prints are smooth, slightly glossy, clear in details, and rich in subtle gradations of tone. Platinum prints are matte, silvery-gray or bluish-gray, and without intense shadows or highlights.

If you are more than a casual photographer, you may want to ask: How did the photographer get this effect? What kind of lens, or aperture setting, or filter, or film, did the photographer use, and why? Has the picture been cropped, and why?

Another Look at the Questions

In short, you can stimulate responses (and understanding) by asking yourself two kinds of questions:

1. *What is this doing?* Why is this figure here and not there? Why is the work in bronze rather than in marble? Or put it this way: What is the artist up to?
2. *Why do I have this response?* Why do I find this landscape oppressive, this child sentimental but that child fascinating? That is, how did the artist manipulate the materials in order to produce the strong feelings that I experience?

The first of these questions (What is this doing?) requires you to identify yourself with the artist, wondering, perhaps, whether pen is better than pencil for this drawing, or watercolor better than oil paint for this painting. One senses that Eugene J. Johnson may have put to himself questions of this sort before making the following points about Eero Saarinen's Terminal Building at Dulles International Airport (1958–62):

> Rising majestically out of the flat countryside, the broad, low structure echoes, in its strong horizontal roof supported by regularly spaced posts, the classical architecture of Washington, and perhaps even the great porch of George Washington's house at nearby Mount Vernon. Indeed, the whole terminal is a porch. Departing or arriving, the traveler experiences the building as a semi-enclosed space that lies between the enclosed space of the airplane or of the bus that brings the traveler to the terminal proper and the open Virginia landscape that waits outside.
>
> *International Handbook of Contemporary Developments in Architecture,* ed. Warren Sanderson (Westport, Conn.: 1981), p. 509

Sometimes artists tell us what they are up to. Van Gogh, for example, in a letter to his brother, helps us to understand why he put a blue background behind the portrait of a blond artist: "Behind the head, instead of painting the ordinary wall of the mean room, I paint infinity, a plain background of the richest, intensest blue that I can contrive, and by the simple combination of the bright head against the rich blue background, I get a mysterious effect, like a star in the depths of an azure sky." But, of course, you cannot rely

Doonesbury

BY GARRY TRUDEAU

Doonesbury, August 28, 1985. Copyright 1985 G. B. Trudeau. Reprinted with permission of Universal Press Syndicate. All rights reserved.

on the artist's statement of intention; the intention may not be ful-
filled in the work itself.

The second question (Why do I have this response?) requires
you to trust your feelings. If you are amused or repelled or un-
nerved or soothed, assume that these responses are appropriate and
follow them up — but not so rigidly that you exclude the possibil-
ity of other, even contradictory feelings. (The important comple-
ment to "Trust your feelings" is "Trust the work of art." The study
of art ought to enlarge feelings, not merely confirm them.)

Questions like these are not childish; excellent scholars have
left traces of them in their writings. Nikolaus Pevsner, for example,
writes of Michelangelo's sculptures in the ducal tombs in the Med-
ici Chapel:

> The question has often been asked what made him keep the untreat-
> ed stone below his reclining figures of *Day and Night* and *Morning
> and Evening*. The answer is that he wanted to let them appear in the
> act of coming to life out of a stony, subhuman preexistence. To shape
> the image of man entirely liberated from these dark forces must have
> seemed almost a sacrilege to the young and again the very old
> Michelangelo. Hence also his many unfinished works.
> "The Architecture of Mannerism," *The Mint,* I (1946);
> in *Readings in Art History,* 2d ed., ed. Harold
> Spencer (New York: Scribner's, 1976), II, 121

Here is another example; this time the writer asks a question but
can't answer it. Kenneth Clark is talking about Rembrandt's *Samson
Betrayed by Delilah.*

> Incidentally, the Macbeth-like figure in the back must be one of the
> earliest representations in art of a kilt and plaid. How did Rembrandt
> come by it? Had he seen a drawing of a Highlander, or is it based
> on some engraving of a barbarian on Trajan's column?
> *An Introduction to Rembrandt*
> (New York: Harper & Row, 1978), p. 54

Someday an art historian will turn up a convincing answer, and it
will help us — even though only to a tiny degree — better to un-
derstand Rembrandt's art.

In fact, art-historical research is largely an attempt to explain
certain results — let's say, the new style of painting that arose in

Flanders in about 1420 — by setting forth causes. That is, the historian asks, Why, and searches for explanations.

FORMAL ANALYSIS OR DESCRIPTION?

First, it should be understood that the word *formal* in "formal analysis" is not used as the opposite of *informal,* as in a formal dinner or a formal dance. Rather, a formal analysis is an analysis of the form the artist produces, that is, an analysis of the work of art, which is made up of such things as line, shape, color, texture. These things give the stone or canvas its form, its expression, its content, its meaning. Second, it should be mentioned that sometimes a distinction is made between formal analysis — an analysis of the configuration of the artistic object itself — and stylistic analysis — an analysis that can include discussion of similar features in related objects; but we need not preserve this distinction.

Is the term *formal analysis* merely a pretentious substitute for *description?* Not quite. A description deals with the relatively obvious, reporting what any eye might see: "A woman in a white dress sits at a table, reading a letter. Behind her, . . ." It can also comment on the execution of the work ("thick strokes of paint," "the highly polished surface"), but it does not offer inferences and it does not evaluate. A description tells us, for example, that the head of a certain portrait sculpture "faces front; the upper part of the nose and the rim of the right earlobe are missing. . . . The closely cropped beard and mustache are indicated by short random strokes of the chisel," and so forth.

These statements, from an entry in the catalog of an exhibition, are all true and they can be useful, but they scarcely reveal the thought, the reflectiveness, that we associate with analysis. When the entry in the catalog goes on, however, to say that "the surfaces below the eyes and cheeks are sensitively modeled to suggest the soft, fleshly forms of age," we begin to feel that now indeed we are reading an analysis. Similarly, although the statement that "the surface is in excellent condition" is purely descriptive (despite the apparent value judgment in "excellent"), the statement that the

"dominating block form" of the portrait contributes to "the impression of frozen tension" can reasonably be called analytic.

Much of any formal analysis will inevitably consist of description ("The pupils of the eyes are turned upward"), and accurate descriptive writing itself requires careful observation of the object and careful use of words. But an essay is a formal analysis rather than a description only if it seeks to show *how* the described object works. For example, "The pupils of the eyes are turned upward, suggesting a heaven-fixed gaze, or, more bluntly, suggesting that the figure is divinely inspired."

Another way of putting it is to say that analysis tries to answer the somewhat odd-sounding question, *"How* does the work mean?" Thus, the following paragraph is chiefly analytic rather than descriptive. The author has made the point that a Protestant church emphasizes neither the altar nor the pulpit: "as befits the universal priesthood of all believers," he says, it is essentially an auditorium. He then goes on to analyze the ways in which a Gothic cathedral says or means something very different:

> The focus of the space on the interior of a Gothic cathedral is . . . compulsive and unrelievedly concentrated. It falls, and falls exclusively, upon the sacrifice that is re-enacted by the mediating act of priest before the altar-table. So therefore, by design, the first light that strikes the eye, as one enters the cathedral, is the jewelled glow of the lancets in the apse, before which the altar-table stands. The pulsating rhythm of the arches in the nave arcade moves toward it; the string-course moldings converge in perspective recession upon it. Above, the groins of the apse radiate from it; the ribshafts which receive them and descend to the floor below return the eye inevitably to it. It is the single part of a Gothic space in which definiteness is certified. In any other place, for any part which the eye may reach, there is always an indefinite beyond, which remains to be explored. Here there is none. The altar-table is the common center in which all movement comes voluntarily to rest.
>
> John F. A. Taylor, *Design and Expression in the Visual Arts* (New York: Dover, 1964), pp. 115–17

In this passage the writer is telling us, analytically, *how* the cathedral means.

STYLE AS THE SHAPER OF FORM

This chapter has in large measure been talking about style, and it is now time to define this elusive word. The first thing to say about **style** is that the word is *not* used by most art historians to convey praise, as in "He has style." Rather, it is used neutrally, for everyone and everything made has a style — good, bad, or indifferent. The person who, as we say, "talks like a book" has a style (probably an annoying one), and the person who keeps saying "Uh, you know what I mean" has a style too (different, but equally annoying). Similarly, whether we wear jeans or painter's pants or gray flannel slacks, we have a style in our dress. We may claim to wear any old thing, but in fact we don't; there are clothes we wouldn't be caught dead in. The clothes we wear are expressive; they announce that we are police officers or bankers or tourists or college students — or at least they show what we want to be thought to be, as when in the sixties many young middle-class students wore tattered clothing, thus showing their allegiance to the poor and their enmity toward what was called the Establishment. It is not silly to think of our clothing as a sort of art that we make. Once we go beyond clothing as something that merely serves the needs of modesty and that provides protection against heat and cold and rain, we get clothing whose style is expressive.

To turn now to our central topic, style in art, we can all instantly tell the difference between a picture by van Gogh and one by Norman Rockwell or Walt Disney, even though the subject matter of all three pictures may be the same, for instance, a seated woman. How can we tell? By the style, that is, by line, color, medium, and so forth — all of the things we talked about earlier in this chapter. Walt Disney's figures tend to be built up out of circles and ovals (think of Mickey Mouse), and the color shows no modeling or traces of brush strokes; Norman Rockwell's methods of depicting figures are different, and van Gogh's are different in yet other ways. Similarly, a Chinese landscape, painted with ink on silk or on paper, simply cannot look like a van Gogh landscape done with oil paint on canvas, partly because the materials prohibit such identity and partly because the Chinese painter's vision of landscape

(usually lofty mountains) is not van Gogh's vision. Their works "say" different things. As the poet Wallace Stevens put it, "A change of style is a change of subject."

We recognize certain *distinguishing characteristics* (from large matters, such as choice of subject and composition, to small matters, such as kinds of brush strokes) that mark an artist, or a period, or a culture, and these constitute the style. Almost anyone can distinguish between a landscape painted by a Chinese and one painted by van Gogh. But it takes considerable familiarity with the styles of Chinese painting to be able to say, "This is a Chinese painting of the seventeenth century, in fact the late seventeenth century. It belongs to the Nanking School and is a work by Kung Hsien — not by a follower, and certainly not a copy, but the genuine article."

Style, then, is revealed in **form;** an artist creates form by applying certain techniques to certain materials, in order to embody a particular vision or content. In different ages people have seen things differently: the nude body as splendid, or the nude body as shameful; Jesus as majestic ruler, or Jesus as the sufferer on the cross; landscape as pleasant, domesticated countryside, or landscape as wild nature. So the chosen subject matter is not only part of the content, but is also part of that assemblage of distinguishing characteristics that constitutes a style.

All of the elements of style, finally, are expressive. Take ceramics as an example. The kind of clay, the degree of heat at which it is baked, the decoration or glaze (if any), the shape of the vessel, the thickness of its wall, all are elements of the potter's style, and all contribute to the expressive form. But every expressive form is not available in every age; certain visions, and certain technologies, are, in certain ages, unavailable. Porcelain, as opposed to pottery, requires a particular kind of clay and an extremely high temperature in the kiln, and these were simply not available to the earliest Japanese potters. In fact, even the potter's wheel was not available to them; they built their pots by coiling ropes of clay and then, sometimes, they smoothed the surface with a spatula. The result is a kind of thick-walled, low-fired ceramic that expresses energy and earthiness, far different from those delicate Chinese porcelains that express courtliness and the power of technology (or, we might say, of art).

PERSONAL STYLE AND PERIOD STYLE

Although each work that an artist produces is an individual work, it is evident that there must be family resemblances among the works, for not even the greatest artists can totally escape the limitation of their age and of their own vision. And so we can reasonably speak of van Gogh's style, or, in an effort to be more precise, of his early or late style, or of his style in still life and of his style in portraiture. We recognize that each work has individual traits, but we find some connections among works. No one questions the usefulness of talking about an artist's personal style — well, no one except Picasso, who denied that he had a style and who liked to believe that each work was a new answer to a new problem.

How useful is it, however, to speak not of the personal style of an individual artist but of the style of a century or so, that is, of a *period style?* The term, of course, has some validity, for the works of a period at least to some degree share certain features, for reasons of materials and technology, most obviously, but also perhaps because of a shared vision. One may see a resemblance, for instance, between the sculpture and the architecture of a given period. Let's take as an example Roman sculpture and architecture of the early fourth century, but first we must briefly look at what preceded it. Roman portrait sculpture of the first two and a half centuries A.D. shows a personality *in time,* caught in the act of raising an eyebrow, or frowning, or looking at the viewer. The face, therefore, is not strictly symmetrical, and the hair, whose texture is suggested, usually seems slightly disordered or at least not highly disciplined. And if we take as an example of architecture Hadrian's palace at Tivoli, we find that its buildings are arranged rather freely, not with strict symmetry. But when we turn to Roman sculpture and architecture at the end of the third century and the beginning of the fourth, we find something different. Roman portrait sculpture now shows faces removed from the world of time. The faces are more strictly symmetrical, the hair much more severely patterned, the eyes unnaturally large and staring, the whole face somewhat cubic and masklike rather than highly imitative of a natural form. The eight-foot-high head of Constantine the Great (A.D. 330) is an example

Roman, *Constantine the Great,* ca. A.D. 330. Marble, 8′6″. Palazzo dei Conservatori, Rome. (Hirmer Fotoarchiv, Hirmer Verlag, München)

Palace of Diocletian, A.D. 300–305. Spalato (Split). Reconstruction by
E. Hebrard. (Alinari/Art Resource)

of this later Roman style; nothing like it existed in the previous two
and a half centuries. And this change in sculpture seems to be par-
alleled by a change in architecture, for Diocletian's palace at Spalato
(A.D. 300–305, in Yugoslavia) is strictly symmetrical, a massive,
seemingly impenetrable block.

And so it can be argued that in a given period we see a stylistic
similarity — a period style — in different kinds of works of art.
Moreover, one can argue that this massive, cubic, consolidated
style reflects the spirit of the age, for Constantine, an absolute ruler,
established a centralized bureaucracy and did much to unify the
Roman Empire.

Yet, a word of caution is necessary in a discussion of period
style. Most of us have a tendency to try to make order out of chaos,
to see connections even where there may not be connections, and
historians (including art historians) are not exceptions. For in-
stance, the historian who tries to catch the spirit of the age of the
Gothic period may tell us that it can be seen not only in its painting,

sculpture, and architecture but also in its philosophy. The assumption (often unstated) is that all of the activities of a period *must* be related, or, to put it in other words, that there *is* a period style. Thus, it has been said that Gothic art is fond of innumerable subdivisions and multiplicity of forms and that we find these qualities not only in a cathedral but also in the writings of Thomas Aquinas. But how far can we push this idea that a period manifests a spirit in all of its productions? The very term *Gothic period* is a historian's invention, an attempt to impose order. Having imposed this simplification, the historian then begins to feel a bit uneasy and distinguishes between Early Gothic and Late Gothic, then between Early English Gothic and Early French Gothic, and so on. Is there really an all-embracing style in a given period? One can be skeptical, and a simple analogy may be useful. A family often consists of radically different personalities, improvident husband, patient wife, one son an idler and the other a go-getter, one daughter wise in her choice of career and the other daughter unwise. And yet all may have come from the same culture. Or take the individual: A man may have wretched table manners, but he may also paint beautifully.

A Gothic painting, of course, resembles other Gothic paintings infinitely more than it resembles a painting by Rembrandt, and a Gothic painting may bear some resemblances to Gothic architecture. It may even in some ways resemble medieval law — but then again, it may not. We do well when we try to see the hidden connections between things, but we do badly when we suppress the rich, individualizing details that give a work its value and we see only some forced and not very interesting similarity. It is useful to keep in mind Bishop Butler's words: "Everything is what it is, and not another thing."

SAMPLE ESSAYS: TWO FORMAL ANALYSES

The first analysis, by an undergraduate, includes a good deal of description and is conspicuously impersonal, but notice that even this apparently dispassionate assertion of facts is shaped by a *thesis:* The sculpture successfully combines a highly conventional symmetrical style, on the one hand, with mild asymmetry and a degree of realism on the other.

The second analysis, also by an undergraduate, is somewhat more personal (notice the opening sentence), but it, too, is chiefly a report on the object (how the form expresses content) rather than a report of casual impressions.

Stephen Beer

Formal Analysis: <u>Prince Khunera as a Scribe</u>

<u>Prince Khunera as a Scribe</u>, a free-standing Egyptian sculpture twelve inches tall, now in the Museum of Fine Arts, Boston, was found at Giza in a temple dedicated to the father of the prince, King Mycerinus. The limestone statue may have been a tribute to that Fourth Dynasty king.[1] The prince, sitting cross-legged with a scribal tablet on his lap, rests his hands on his thighs. He wears only a short skirt or kilt.

The statue is in excellent condition although it is missing its right forearm and hand. Fragments of the left leg and the scribe's tablet also have been lost. The lack of any difference in the carving between the bare stomach and the kilt suggests that these two features were once differentiated by contrasting paint that has now faded, but the only traces of paint remaining on the figure are bits of black on the hair and eyes.

The statue is symmetrical, composed along a vertical axis which runs from the crown of the head into the base of the sculpture. The sculptor has relied on

[1]Museum label.

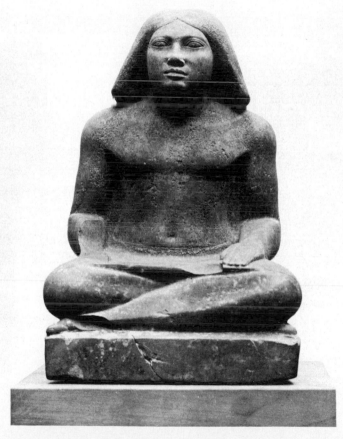

Egyptian, *Seated Statue of Prince Khunera* (or *Khuenre*) *as a Scribe,* Dynasty IV (2599–2571 B.C.). Yellow limestone, 12″. Museum of Fine Arts, Boston. (Harvard-Boston Expedition)

basic geometric forms in shaping the statue on either
side of this axis. Thus, the piece could be described
as a circle (the head) within a triangle (the wig)
which sits atop a square and two rectangles (the
torso, the crossed legs, and the base). The reliance
on basic geometric forms reveals itself even in de-
tails. For example, the forehead is depicted as a
small triangle within the larger triangular form of
the headdress.

On closer inspection, however, one observes that
the rigidity of both this geometric and symmetric or-
ganization is relieved by the artist's sensitivity to
detail and by his ability as a sculptor. None of the
shapes of the work is a true geometric form. The full,
rounded face is more of an oval than a circle, but
actually it is neither. The silhouette of the upper
part of the body is defined by softly undulating lines
that represent the muscles of the arms and that modify
the simplicity of a strictly square shape. Where the
prince's naked torso meets his kilt, just below the
waist, the sculptor has suggested portliness by al-
lowing the form of the stomach to swell slightly. Even
the ''circular'' navel is flattened into an irregular
shape by the suggested weight of the body. The con-
tours of the base, a simple matter at first glance,
actually are not exactly four-square but rather are
slightly curvilinear. Nor is the symmetry on either
side of the vertical axis perfect: Both the mouth and
the nose are slightly askew; the right and left fore-

arms originally struck different poses; and the left
leg is given prominence over the right. These depar-
tures from symmetry and from geometry enliven the
statue, giving it both an individuality and a person-
ality.

Although most of the statue is carved in broad
planes, the sculptor has paid particular attention to
details in the head. There he attempted to render
precisely and with apparent descriptive accuracy the
details of the prince's face. The parts of the eye,
for example — the eyebrow, eyelids, eyeballs, and
sockets — are distinct. Elsewhere the artist has not
worked in such probing detail. The breasts, for exam-
ple, are rendered in large forms, the nipples being
absent. The attention to the details of the face sug-
gests that the artist attempted to render a lifelike-
ness of the prince himself.

The prince is represented in a scribe's pose but
without a scribe's tools. The prince is not actually
doing anything. He merely sits. The absence of any
open spaces (for example, between the elbows and the
waist) contributes to the figure's composure or self-
containment. But if he sits, he sits attentively:
There is nothing static here. The slight upward tilt
of the head and the suggestion of an upward gaze of
the eyes give the impression that the alert prince is
attending someone else, perhaps his father the king.
The suggestion in the statue is one of imminent work
rather than of work in process.

Thus, the statue, with its variations from geometric order, suggests the presence, in stone, of a particular man. The pose may be standard and the outer form may appear rigid at first, yet the sculptor has managed to depict an individual. The details of the face and the overfleshed belly reveal an intent to portray a person, not just a member of the scribal profession. Surely when freshly painted these elements of individuality within the confines of conventional forms and geometric structure were even more compelling.

Joan Daremo

Edvard Munch's The Scream

Is there a more unnerving work of art than Munch's lithograph of 1896? Even his painting of the same subject, two years earlier, by virtue of its color (rather than severely contrasting black and white spaces) seems less filled with anguish. This lithograph is almost unbearably agitated: Although the two little boats seem to rest easily on the water, our eyes cannot rest on them, for the thrusting diagonals pull the eyes to the left rear, yet the compelling picture of the central anguished figure pulls them forward again. Perhaps there is some calm in the heavens (although even in the sky the vigorous undulating horizontal lines are full of motion) as well as in the water, but the isolated figure in the center is

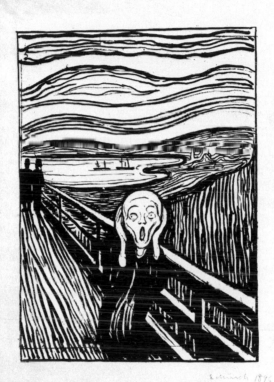

Geschrei

Ich fühlte das grosse Geschrei
durch die Natur

Edvard Munch. *The Scream* (or *The Shriek*), 1896. Lithograph, printed in black, 20⅝″ × 15¹³⁄₁₆″. Collection, The Museum of Modern Art, New York. (Matthew T. Mellon Fund)

surrounded by, and seems assaulted by, strongly con-
flicting lines — at the right, verticals that crash
into horizontals, and at the left, the diagonals.

At the left, too, walking out of the picture and
thus away from the chief figure, two figures stand
near each other, forming, we might say, the society
from which the central figure is excluded. But even
these two figures are separated from each other by a
narrow space (this is not a world in which someone can
put an arm on another's shoulder) and, more important,
by the fact that they are looking in different direc-
tions. These two stiff passersby apparently muse on
the water, but the screaming wobbly figure, whose
bones seem to have dissolved from terror, averts its
eyes from (and closes it ears to) the seething sur-
rounding world; it (the figure seems sexless, almost a
skull, though some people perceive a female) faces
nothing but us, or, rather, the empty space which we
occupy, for its eyes are not focused together.

3
Writing a Comparison

THE USES OF COMPARISON

Analysis frequently involves comparing: Things are examined for their resemblances to and differences from other things. Strictly speaking, if one emphasizes the differences rather than the similarities, one is contrasting rather than comparing, but we need not preserve this distinction; we can call both processes *comparing*.

Although your instructor may ask you to write a comparison of two works of art, the *subject* of the essay is the *works*. *Comparison* is simply an effective analytic *technique* to show some of the qualities of the works. For example, in a course in architecture you may compare two subway stations (considering the efficiency of the pedestrian patterns, the amenities, and the esthetic qualities), with the result that you may come to understand both of them more fully; but a comparison of a subway station with a dormitory, no matter how elegantly written the comparison is, can hardly teach the reader or the writer anything.

Art historians almost always use comparison in discussing authenticity: A work of uncertain attribution is compared with undoubtedly genuine works, on the assumption that if the uncertain work, when closely compared with genuine works, somewhow is markedly different, perhaps in brush technique, it is probably not genuine despite superficial similarities of, say, subject matter and medium. (This assumption can be challenged — a given artist may

have produced a work with unique characteristics — but it is nevertheless widely held.) Similarly, in holding the assumption that certain qualities in a work indicate the period, the school, perhaps the artist and even the period within the artist's career, historians frequently make use of comparisons in trying to date a work.

Let's assume that there is no doubt about who painted a particular picture, and that the problem is the date of the work. By comparing this work with a picture that the artist is known to have done in, say, 1850, and with yet another that the artist is known to have done in 1870, one may be able to conjecture that the undated picture was done, say, midway between the dated works, or that it is close in time to one or to the other.

Again the assumption (here, that contemporary works by an artist necessarily resemble each other closely) is widely held and it often seems to produce reasonable results, but it can be challenged. Manet's *Woman Writing* (see frontispiece) can be dated fairly precisely because it is inscribed to John Leech, and we know that Manet first met Leech in 1862, and that Leech died in 1864. Yet Françoise Cachin, coauthor of a splendid catalog entitled *Manet,* admits in her discussion of *Woman Writing* that "This drawing, so spontaneous and free, would certainly have been assigned a date in the late 1870s were it not for the dedication." To complicate things still further, it should be added that although the evidence for the date of Manet's drawing is conclusive, even a date inscribed by the artist does not always provide trustworthy evidence. For example, Mondrian in the 1940s added dates to some of his earlier paintings, but he was occasionally mistaken and dated several of them incorrectly by a few years.

The assumptions underlying the uses of comparison are that an expert can not only recognize the stylistic characteristics of an artist, but can also identify those that are permanent and can establish the chronology of those that are temporary. In practice these assumptions are usually based on yet another assumption: A given artist's early works are relatively immature; the artist then matures, and if there are some dated works, we can with some precision trace this development or evolution. Whatever the merits of these assumptions, comparison is a tool by which students of art often seek to establish authenticity and chronology.

TWO WAYS OF ORGANIZING
A COMPARISON

Probably a student's first thought, after making some jottings, is to discuss one work and then go on to the second work. Instructors and textbooks (though not this one) usually condemn such an organization, arguing that the essay breaks into two parts and that the second part involves a good deal of repetition of categories set up in the first part. Usually they recommend that the students organize their thoughts differently, somewhat along these lines:

1. general introduction of the two objects, X and Y
2. first point (e.g., subject matter)
 a. similarities between X and Y
 b. differences between X and Y
3. second point (e.g., medium)
 a. similarities between X and Y
 b. differences between X and Y

and so on, making as many points as seem appropriate. Here is an outline, paragraph by paragraph, of a short essay of this sort, comparing two fifteenth-century Italian low-relief carvings of the Madonna and Child, one by Desiderio da Settignano, the other by Agostino di Duccio. The essay itself is printed later in this chapter on pages 70–73.

> The two were contemporaries, but their work is markedly different. Desiderio's Madonna has a "natural, homely humanity while Agostino's is elegantly aristocratic."

> The differences are evident if we look at the hair; in Desiderio it is less clearly defined than in Agostino, who "treated the hair as a highly stylized pattern of regular lines." The drapery reveals a similar difference.

> A comparison of the right forearms and hands of the two Virgins reveals a difference. Agostino . . .; Desiderio. . . .

> The outlines and modeling of the contours differ.

Conclusion: This is not to say that Agostino's relief is more carefully designed or that Desiderio's is more naturalistic — only that Desiderio's design is less obtrusive.

In a comparison it is usually advisable to begin by defining the main issue — here, although the works are of the same period, one depicts "homely humanity," the other depicts "aristocratic" figures. Then proceed with a comparative analysis, probably treating first the major aspects (e.g., composition, space, color) and next the finer points.

But a comparison need not employ this structure, and indeed an essay that does employ it too rigidly is likely to produce a ping-pong effect. There is also the danger that the essay will not come into focus — the point will not be grasped — until the essayist stands back from the seven-layer cake and announces, in the concluding paragraph, that the odd layers taste better. In one's preparatory thinking one may want to make the comparisons in pairs (line in Desiderio, line in Agostino; hair in each; treatment of arms in each, etc.), but one must come to some conclusions about what these add up to *before* writing the final version. This final version should not duplicate the thought processes; rather, since the point of a comparison is *to make a point,* it should be organized so as to make the point clearly and effectively. After reflection one may believe that although there are superficial similarities between X and Y, there are essential differences; in the finished essay, then, one probably will not wish to obscure the main point by jumping back and forth from one work to the other, working through a series of similarities and differences. It may be better to discuss X and then Y. Some repetition in the second half of the essay (e.g., "In contrast to the rather nervous lines of X, in Y we get . . .") will serve to bind the two halves into a meaningful whole, making clear the degree of similarity or difference. The point of the essay presumably is not to list pairs of similarities or differences but to illuminate a work, or works, by making thoughtful comparisons.

Although in a long essay one cannot postpone until, say, page 30 a discussion of the second half of the comparison, in an essay of, say, fewer than ten pages, there is nothing wrong with setting forth half of the comparison and then, in light of it, the second half. The essay will break into two unrelated parts if the second half

makes no use of the first, or if it fails to modify the first half, but not if the second half looks back to the first half and calls attention to differences that the new material reveals.

Finally, remember that the point of a comparison is to call attention to the unique features of something by holding it up against something similar but significantly different. If the differences are great and apparent, a comparison is a waste of effort. (Blueberries are different from elephants. Blueberries do not have trunks. And elephants do not grow on bushes.) Indeed, a comparison between essentially and obviously unlike things can only obscure, for by making the comparison, the writer implies that there are significant similarities, and readers can only wonder why they do not see them. The essays that do break into two unrelated halves are essays that make uninstructive comparisons: The first half tells the reader about five qualities in El Greco; the second half tells the reader about five different qualities in Rembrandt. Notice in Bedell's essay (p. 73) that the second half occasionally looks back to the first half.

SAMPLE ESSAYS: TWO COMPARISONS

The first of these essays, already glanced at on page 67, is reprinted from a book. It compares two objects more or less simultaneously. The second essay, by an undergraduate, discusses one object first and then discusses the second. Her essay does not break into two separate parts because at the start she looks forward to the second object, and in the second half of the essay she occasionally reminds us of the first object.

By the way, when you read the student's essay on Copley, don't let its excellence discourage you into thinking that you can't do as well. This essay, keep in mind, is the product of much writing and rewriting. As Bedell wrote, her ideas got better and better, for in her drafts she sometimes put down a point and then realized that it needed strengthening (e.g., with concrete details) or that — come to think of it — the point was wrong and ought to be deleted. She also derived some minor assistance — for facts, not for her fundamental thinking — from books, which she cites in her footnotes.

Two Low Relief Carvings from the Fifteenth Century
L. R. Rogers

===

We turn now to two fifteenth-century Italian low relief carvings on the theme of the Madonna and Child. Desiderio da Settignano's all too short thirty-five years of life (1430–64) began and ended during the lifetime of Agostino di Duccio (1418–81). Yet although the two artists were contemporaries who almost certainly knew of each other's work, it would be difficult to find two artists who display a greater difference in the qualities of their lines. Desiderio's lines are full of minute changes of direction and breaks in continuity. They have a nervous delicacy, a gentleness, and quiet unassertiveness which is appropriate, in our example, to the character and mood expressed in a more directly psychological way in the faces of Mary and the Child. They are neither rhetorical nor merely decorative but describe the form and represent material qualities in a naturalistic manner. These is nothing arbitrary about them. For the most part they are not clear-cut lines; their depth and intensity varies and they have an irregular scratched rather than a sharp-edged quality. Many of them are little more than short incised "touches" with the chisel. Agostino's relief is also gentle and delicate but it is in every respect more self-consciously "designed," more contrived, than Desiderio's. Both Madonnas are human rather than divine but Desiderio's is a natural, homely humanity while Agostino's is elegantly aristocratic and artificial. If there is anything supernatural about Agostino's relief, it is a supernatural prettiness and sweetness.

The differences between the two works may be brought out more clearly if we compare a few details. Consider the treatment of the hair. In Desiderio's relief it is rendered as a vaguely unified plastic mass in which curls are merely hinted at by irregular incised lines. The hair of Desiderio's Child has a soft, downy appearance and merges with the form of the forehead without any clear line of demarcation. Agostino, on the other hand, has treated the hair as a highly stylized pattern of regular lines. These fall into graceful waves, and on the Child they twist round to form elegant tight little spiral curls. A similar difference pervades the drapery of the two reliefs. Desiderio's treatment is spare, full of irregularities, crumpled passages, and straightness. There are no lines which seem to be there purely for their own sake. Agostino's lines on the other hand are mostly decorative and are intended to be enjoyed for their own sake. They are full of graceful curves and elegant rhythms and counter-

Desiderio da Settignano, *Virgin and Child*, 1455–60. Marble,
23¼" × 17¾". Philadelphia Museum of Art. (Purchased by the Wilstach
Committee)

Agostino di Duccio, *Virgin and Child with Four Angels,* ca. 1460. Marble, 35″ × 30¼″. The Louvre, Paris.

rhythms. Their linear design is confidently, even exuberantly, lyrical.

A comparison of the similarly positioned right forearms and hands of the two Virgins is most revealing. Agostino makes one continuous curve of the upper line of the forearm and the hand and carries the line right through to the ends of the extended first finger and thumb. But the line of Desiderio's arm and hand changes direction abruptly where the hand broadens out at the wrist. And although there is a connection through from the arm across the hand and into the extended finger, it is a straight line, not an elegant curve,

and it is not continuous. Notice, too, the contrast in the lines of the fingers themselves in the two reliefs.

The outlines of the fleshy parts of Desiderio's figures — the head, arms, and shoulders of the Child, for example — are softer and more variable than those of Agostino's. This is true also of the modeling inside the contours. The lines down the left arms of both infants clearly show the difference. Finally, the lines of the facial features — the center line of the nose, the outlines of the lips and the eyes — are sharper in the Agostino than in the Desiderio, where their softness contributes to the "dewy" look of the faces.

It would be wrong to conclude from all this that Agostino's relief is more carefully designed and that Desiderio's merely describes the forms naturalistically. Desiderio's relief is in fact designed with extreme care and sensitivity. Indeed, according to John Pope-Hennessy, "in composition this is Desiderio's finest and most inventive Madonna relief."* Pope-Hennessy does complain, however, that its execution is "rather dry" and inferior to that of some of the sculptor's other works. The crux of the matter is that in this work of Desiderio's the design is less obtrusive than it is in the Agostino.

Brief marginal annotations have been added to the following essay in order to help you appreciate the writer's skill in presenting her ideas.

<div style="text-align: right;">Rebecca Bedell</div>

Title is focused

<div style="text-align: center;">

John Singleton Copley's Early Development:

From <u>Mrs. Joseph Mann</u> to

<u>Mrs. Ezekial Goldthwait</u>

</div>

Opening paragraph is unusually personal but engaging, and it implies the problem the writer will address

Several Sundays ago while I was wandering through the American painting section of the Museum of Fine Arts, a professorial bellow shook me. Around the corner strode a well-

Italian Renaissance Sculpture (London: Phaidon, 1958), p. 303.

dressed mustachioed member of the art histori-
cal elite, a gaggle of note-taking students
following in his wake. ''And here,'' he said,
''we have John Singleton Copley.'' He mar-
shalled his group about the rotunda, explain-
ing that, ''as one can easily see from these
paintings, Copley never really learned to
paint until he went to England.''

Thesis is clearly an-
nounced

A walk around the rotunda together with a
quick leafing through a catalog of Copley's
work should convince any viewer that Copley
reached his artistic maturity years before he
left for England in 1774. A comparison of two
paintings at the Museum of Fine Arts, Mrs. Jo-
seph Mann of 1753 and Mrs. Ezekial Goldthwait
of ca. 1771, reveals that Copley had made huge
advances in his style and technique even be-
fore he left America; by the time of his de-
parture he was already a great portraitist.
Both paintings are half-length portraits of
seated women, and both are accompanied by
paired portraits of their husbands.

Brief description of
first work

The portrait of Mrs. Joseph Mann, the
twenty-two-year-old wife of a tavern keeper in
Wrentham, Massachusetts,[1] is signed and dated

[1]Jules David Prown, John Singleton Copley
(Cambridge, Mass.: Harvard University Press,
1966), I, 110.

John Singleton Copley, *Mrs. Joseph Mann,* 1753. Oil on canvas,
36″ × 28¼″. Museum of Fine Arts, Boston. (Gift of Frederick H. and
Holbrook E. Metcalf)

J. S. Copley 1753. One of Copley's earliest
known works, painted when he was only fifteen
years old, it depicts a robust young woman
staring candidly at the viewer. Seated out-
doors in front of a rock outcropping, she
rests her left elbow on a classical pedestal
and she dangles a string of pearls from her
left hand.

Relation of the
painting to its
source

The painting suffers from being tied too
closely to its mezzotint prototype. The compo-
sition is an almost exact mirror image of that
used in Isaac Beckett's mezzotint after Wil-
liam Wissing's Princess Anne of ca. 1683.[2]
Pose, props, and background are all lifted di-
rectly from the print. Certain changes, how-
ever, were necessary to acclimatize the image
to its new American setting. Princess Anne is
shown provocatively posed in a landscape set-
ting. Her blouse slips from her shoulders to
reveal an enticing amount of bare bosom. Her
hair curls lasciviously over her shoulders and
a pearl necklace slides suggestively through
her fingers as though, having removed the

[2]Charles Coleman Sellers, ''Mezzotint Pro-
totypes of Colonial Portraiture: A Survey
Based on the Research of Waldon Phoenix Belk-
nap, Jr.,'' Art Quarterly, 20 (1957), 407–68.
See especially plate 16.

pearls, she will proceed further to disrobe. But Copley reduces the sensual overtones. Mrs. Mann's bodice is decorously raised to insure sufficient coverage, and the alluring gaze of the princess is replaced by a cool stare. However, the suggestive pearls remain intact, producing an oddly discordant note.

First sentence of paragraph is both a transition and a topic sentence: the weakness of the painting

The picture has other problems as well. The young Copley obviously had not yet learned to handle his medium. The brush strokes are long and streaky. The shadows around the nose are a repellent greenish purple and the high light on the bridge was placed too far to one side. The highlights in the hair were applied while the underlying brown layer was still wet so that instead of gleaming curls he produced dull gray smudges. In addition, textural differentiation is noticeably lacking. The texture of the rock is the same as the skin,

Concrete details support the paragraph's opening assertion

which is the same as the satin and the grass and the pearls. The anatomy is laughable: There is no sense of underlying structure. The arms and neck are the inflated tubes so typical of provincial portraiture. The left earlobe is missing and the little finger on the left hand is disturbingly disjointed. Light too appears to have given Copley trouble. It seems, in general, to fall from the upper left, but the shadows are not consistently ap-

plied. And the light—dark contrasts are rather
too sharp, probably due to an overreliance on
the mezzotint source.

Transition ("Despite its faults") and statement of idea that unifies the paragraph

Despite its faults, however, the painting
still represents a remarkable achievement for
a boy of fifteen. In the crisp linearity of
the design, the sense of weight and bulk of
the figure, the hint of a psychological pres—
ence, and especially in the rich vibrant
color, Copley has already rivaled and even
surpassed the colonial painters of the pre—
vious generation.

Transition ("about seventeen years later") and reassertion of central thesis

In *Mrs. Ezekial Goldthwait*, about seven—
teen years later and about four years before
Copley went to England, all the early inept—
ness had disappeared. Copley has arrived at a
style that is both uniquely his own and
uniquely American; and in this style he
achieves a level of quality comparable to any
of his English contemporaries.

Brief description of second picture

The substantial form of Mrs. Goldthwait
dominates the canvas. She is seated at a round
tilt—top table, one hand extended over a
tempting plate of apples, oranges, and pears.
A huge column rises in the right—hand corner
to fill the void.

Biography, and (in rest of paragraph) its relevance to the work

The fifty—seven—year—old Mrs. Goldthwait,
wife of a wealthy Boston merchant, was the
mother of fourteen children; she was also a

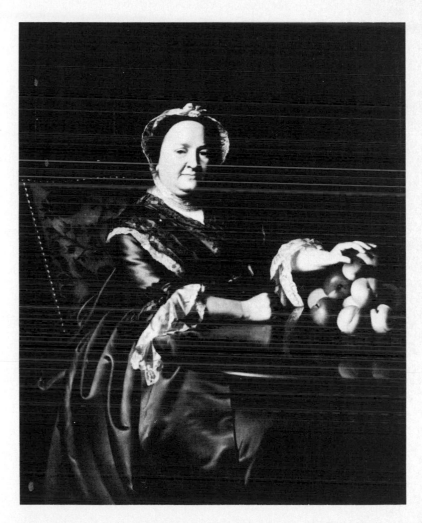

John Singleton Copley, *Mrs. Ezekial Goldthwait,* 1771. Oil on canvas, 50″ × 40″. Museum of Fine Arts, Boston. (Bequest of John T. Bowen in memory of Eliza M. Bowen)

gardener noted for her elaborate plantings.[3]
Copley uses this fertility theme as a unifying
element in his composition. All the forms are
plump and heavy, like Mrs. Goldthwait herself.
The ripe, succulent fruit, the heavy, rotund
mass of the column, the round top of the table
— all are suggestive of the fecundity of the
sitter.

The most obvious
characteristic of the
work

The painting is also marked by a painstak-
ing realism. Each detail has been carefully
and accurately rendered, from the wart on her
forehead to the wood grain of the tabletop to
the lustrous gleam of the pearl necklace. As a
painter of fabrics Copley surpasses all his
contemporaries. The sheen of the satin, the
rough, crinkly surface of the black lace, the
smooth, translucent material of the cuffs —
all are exquisitely rendered.

"But" is transi-
tional, taking us
from the obvious
(clothing) to the
less obvious (char-
acter)

But the figure is more than a mannequin
modeling a delicious dress. She has weight and
bulk, which make her physical presence undeni-
able. Her face radiates intelligence, and her
open, friendly personality is suggested by the
slight smile at the corner of her lips and by
her warm, candid gaze.

[3]Prown, p. 76.

Brief reminder of the first work, to clarify our understanding of the second work

The rubbery limbs of Copley's early period have been replaced by a more carefully studied anatomy (not completely convincing, but still a remarkable achievement given that he was unable to dissect or to draw from nude models). There is some sense for the underlying armature of bone and muscle, especially in the forehead and hands. And in her right hand it is even possible to see the veins running under her skin.

Further comparison again with emphasis on second work

Light is also treated with far greater sophistication. The chiaroscuro is so strong and rich that it calls to mind Caravaggio's tenebroso. The light falls almost like a spotlight onto the face of Mrs. Goldthwait, drawing her forward from the deep shadows of the background, thereby enhancing the sense of a psychological presence.

Reassertion of thesis, supported by concrete details

Copley's early promise as a colorist is fulfilled in mature works such as Mrs. Goldthwait. The rich, warm red-brown tones of the satin, the wood, and the column dominate the composition. But the painting is enlivened by a splash of color on either side — on the left by Copley's favorite aqua in the brocade of the chair, and on the right by the red and green punctuation marks of the fruit. The bright white of the cap, set off against the black background, draws attention to the face,

while the white of the sleeves performs the same function for the hands.

Color, light, form, and line all work to-gether to produce a pleasing composition. It

Summary, but not mere rehash; new details

is pleasing, above all, for the qualities that distinguish it from contemporary English works: for its insistence on fidelity to fact, for its forthright realism, for the lovingly delineated textures, for the crisp clarity of every line, for Mrs. Goldthwait's charming wart and her friendly double chin, for the very materialism that marks this painting as emerging from our pragmatic mercantile soci-ety. In these attributes lie the greatness of the American Copleys.

Not that I want to say that Copley never produced a decent painting once he arrived in

Further summary, again heightening thesis

England. He did. But what distinguishes the best of his English works (see, for example, Mrs. John Montressor and Mrs. Daniel Denison Rogers)[4] is not the facile, flowery brushwork or the fluttery drapery (which he picked up from current English practice) but the very qualities that also mark the best of his Amer-ican works — the realism, the sense of person-ality, the almost touchable textures of the

[4]Prown, plates.

fabrics, and the direct way in which the sit-
ter's gaze engages the viewer. Copley was a
fine, competent painter in England, but it was
not the trip to England that made him great.

4

In Brief:
How to Write an
Effective Essay

All writers must work out their own procedures and rituals, but the following suggestions may provide some help.

1. Look at the work or works carefully.

2. Choose a worthwhile and compassable subject, something that interests you and is not so big that your handling of it must be superficial. As you work, shape your topic, narrowing it, for example, from "Egyptian Sculpture" to "Black Africans in Egyptian Sculpture," or from "Frank Lloyd Wright's Development" to "Wright's Johnson Wax Company as an Anticipation of His Guggenheim Museum."

3. Keep looking at the art you are writing about (or reproductions of it), jotting down notes of all relevant matters. You can generate ideas by asking yourself questions, such as those on pages 21–49. As you look and think, reflect on your observations and record them. (By the way, if you are writing about an object in a museum, it is a good idea to choose an object that is reproduced on a postcard; the picture will help you to keep the object in mind when you are back in your room, writing.) If you have an idea, jot

it down; don't assume that you will remember it when you get around to writing your essay. A sheet of paper is a good place for initial jottings, but many people find that in the long run it is easiest to use four-by-six-inch cards, writing on one side only (notes on the reverse side usually get overlooked). Put only one point on each card, and put a brief caption on the card (e.g., Site of *David*); later you can easily rearrange the cards so that relevant notes are grouped together.

4. Sort out your cards into reasonable divisions, and reject cards irrelevant to your topic. As you work you may discover a better way to group your notes, and, of course, you may want to add to your notes. If so, start reorganizing.

On the whole, it is usually best to devote the beginning of your paper to a statement of the problem, then to go on to an objective discussion of how the object is structured artistically (e.g., composition, space, line, light), and then, finally, to give a more general interpretation and evaluation. Such an organization takes the reader with you; the reader sees the evidence and thus is prepared to accept your conclusions. In general, organize the material from the simple to the complex, in order to insure intelligibility. If, for instance, you are discussing the composition of a painting, it probably will be best to begin with the most obvious points, and then to turn to the subtler but perhaps equally important ones. Similarly, if you are comparing two sculptures, it may be best to move from the most obvious contrasts to the least obvious. When you have arranged your notes into a meaningful sequence of packets, you have approximately divided your material into paragraphs.

5. Get it down on paper. Most essayists find it useful to jot down some sort of **outline,** indicating the main idea of each paragraph and, under each main idea, supporting details that give it substance. An outline — not necessarily anything highly formal with capital and lowercase letters and roman and arabic numerals but merely key phrases in some sort of order — will help you to overcome the paralysis called "writer's block" that commonly afflicts professionals as well as students. A page of paper with ideas in some sort of sequence, however rough, ought to encourage you that you do have something to say. And so, despite the temptation

to sharpen another pencil or to put a new ribbon into the type-writer, the best thing to do at this point is to follow the advice of Isaac Asimov, author of 225 books: "Sit down and start writing." If you don't feel that you can work from note cards and a rough outline, try another method: Get something down on paper, writing freely, sloppily, automatically, or whatever, but allow your ideas about what the work means to you and how it conveys its meaning — rough as your ideas may be — to begin to take visible form. If you are like most people, you can't do much precise thinking until you have committed to paper at least a rough sketch of your initial ideas. Later you can push and polish your ideas into shape, perhaps even deleting all of them and starting over, but it's a lot easier to improve your ideas once you see them in front of you than it is to do the job in your head. On paper one word leads to another; in your head one word often blocks another.

Just keep going; you may realize, as you near the end of a sentence, that you no longer believe it. O.K.; be glad that your first idea led you to a better one, and pick up your better one and keep going with it. What you are doing is, in a sense, by trial and error pushing your way not only toward clear expression but toward sharper ideas and richer responses.

6. Keep looking and thinking, asking yourself questions and providing tentative answers, searching for additional material that strengthens or weakens your main point; take account of it in your outline or draft.

7. With your outline or draft in front of you, write a more lucid version, checking your notes for fuller details. If, as you work, you find that some of the points in your earlier jottings are no longer relevant, eliminate them; but make sure that the argument flows from one point to the next. As you write, your ideas will doubtless become clearer; some may prove to be poor ideas. (We rarely know exactly what our ideas are until we have them set down on paper. As the little girl said, replying to the suggestion that she should think before she spoke, "How do I know what I think until I see what I say?") Not until you have written a draft do you really have a strong sense of what you feel and know, and of how good your essay may be.

If you have not already made an outline, at this stage it is

probably advisable to make one, thus ensuring that your draft is orderly. Try to jot down, in sequence, each major point, and each subpoint. You may find that some points need amplification, or that a point made on page 3 really ought to go on page 1.

8. After a suitable interval, preferably a few days, read the draft with a view toward revising it, not with a view toward congratulating yourself. A revision, after all, is a re-vision, a second (and presumably sharper) view. When you revise, you will be in the company of Picasso, who said that in painting a picture he advanced by a series of destructions. A revision — say, the substitution of a precise word for an imprecise one — is not a matter of prettifying but of thinking. As you read, correct things that disturb you (e.g., awkward repetitions that bore, inflated utterances that grate), add supporting detail where the argument is undeveloped (a paragraph of only one or two sentences is usually an undeveloped paragraph), and ruthlessly delete irrelevancies however well written they may be. But remember that a deletion probably requires some adjustment in the preceding and subsequent material. Make sure that the opening and concluding paragraphs are effective (more on this, pp. 107–10), and that between these paragraphs the argument, aided by transitions, runs smoothly. The details should be relevant, the organization reasonable, the argument clear. If you include any quotations, check them for accuracy. Quotations are evidence, usually intended to support your assertions, and it is not nice to alter the evidence, even unintentionally. If there is time (there almost never is), put the revision aside, reread it in a day or two, and revise it again, especially with a view toward shortening it.

9. Type or write a clean copy, following the principles concerning margins, pagination, footnotes, and so on, set forth in Chapter 6. If you have borrowed any ideas, be sure to give credit, usually in footnotes, to your sources. Remember that plagiarism is not limited to the unacknowledged borrowing of words; a borrowed idea, even when put into your own words, requires acknowledgment. (On giving credit to sources, see pp. 119–23.)

10. Proofread and make corrections as explained on pages 114–15.

In short,

1. is the writing true (do you have a point that you state accurately), and
2. is the writing good (do your words and your organization clearly and effectively convey your meaning)?

All of this adds up to Mrs. Beeton's famous recipe: "First catch your hare, then cook it."

5
Style in Writing

PRINCIPLES OF STYLE

Writing is hard work (Lewis Carroll's school in *Alice's Adventures in Wonderland* taught reeling and writhing), and there is no point in fooling ourselves into believing that it is all a matter of inspiration. Many of the books that seem, as we read them, to flow so effortlessly were in fact the product of innumerable revisions. "Hard labor for life" was Conrad's view of his career as a writer. This labor, for the most part, is not directed to prettifying language but to improving one's thoughts and then getting the words that communicate these thoughts exactly. There is no guarantee that effort will pay off, but failure to expend effort is sure to result in writing that will strike the reader as confused. It won't do to comfort yourself with the thought that you have been misunderstood. You may know what you *meant to say,* but your reader is the judge of what indeed you *have said.* Keep in mind Matisse's remark: "When my words were garbled by critics or colleagues, I considered it no fault of theirs but my own, because I had not been clear enough to be comprehended."

Many books have been written on the elements of good writing, but the best way to learn to write is to do your best, revise it a few days later, hand it in, and then study the annotations an experienced reader puts on your essay. In revising the annotated passages, you will learn what your weaknesses are. After drafting your next essay, put it aside for a day or so; when you reread it, preferably aloud, you may find much that bothers you. If the argument does not flow, check to see whether your organization is reasonable and whether you have made adequate transitions. Do not hesitate

to delete interesting but irrelevant material that obscures the argument. Make the necessary revisions again and again if there is time. Revision is indispensable if you wish to avoid (in Somerset Maugham's words) "the impression of writing with the stub of a blunt pencil."

Even though the best way to learn to write is by writing, a few principles can be briefly set forth here. These principles will not suppress your particular voice; rather, they will get rid of static, enabling your voice to come through effectively. You have something to say, but you can say it only after your throat is cleared of "Well, what I meant was" and "It's sort of, well, you know." Your readers do *not* know; they are reading in order to know. The paragraphs that follow are attempts to help you let your individuality speak clearly.

GET THE RIGHT WORD

Denotation

Be sure the word you choose has the right explicit meaning, or **denotation.** Don't say "tragic" when you mean "pathetic," "carving" when you mean "modeling," or "print" when you mean a photographic reproduction of a painting.

Connotation

Be sure the word you choose has the right association or implication — that is, the right **connotation.** Here is an example of a word with the wrong connotation for its context: "Close study will *expose* the strength of Klee's style." "Reveal" would be better than "expose" here; "expose" suggests that some weakness will be brought to light, as in "Close study will expose the flimsiness of the composition."

Concreteness

Catch the richness, complexity, and uniqueness of what you see. Do not write "His expression lacks emotion" if you really mean the expression is icy, or indifferent, or whatever. But con-

creteness is not a matter only of getting the exact word — no easy job in itself. If your reader is (so to speak) to see what you are getting at, you have to provide some details. Instead of writing "The influence of photography on X is small," write "The influence of photography is evident in only six paintings." Compare the rather boring statement, "Thirteenth-century sculpture was colored," or even "Thirteenth-century sculpture was brightly painted and sometimes adorned with colored glass," with these sentences rich in concrete detail:

> Color was an integral part of sculpture and its setting. Face and hands were given their natural colors; mouth, nose, and ears were slightly emphasized; the hair was gilded. Dresses were either covered in flowers or painted in vigorous colors; ornaments, buckles, and hems were highlighted by brilliant colors or even studded with polished stones or colored glass. The whole portal looked like a page from an illuminated manuscript, enlarged on a vast scale.
>
> Marcel Aubert, *The Art of the High Gothic Era,*
> trans. Peter Gorge (New York: Crown, 1965), p. 60

Tone

Remember, when you are writing, *you* are the teacher. You are trying to help someone to see things as you see them, and it is unlikely that either solemnity or heartiness will help anyone see anything your way. There is rarely a need to write that Daumier was "incarcerated" or (at the other extreme) "thrown into the clink." "Imprisoned" or "put into prison" will probably do the job best. Be sure, also, to avoid shifts in tone. Consider this passage, from a book on modern sculpture:

> We forget how tough it was to make a living as a sculptor in this period. Rare were supportive critics, dealers, and patrons.

Although "tough" is pretty casual ("difficult" might be better), "tough" probably would have been acceptable if it had not been followed, grotesquely, by the pomposity of "Rare were supportive critics." The unusual word order (versus the normal order, "Supportive critics were rare") shows a straining for high seriousness that is incompatible with "tough."

Nor will it do to "finagle" with an inappropriate expression by putting it in "quotes." As the previous sentence indicates, the

apologetic quotation marks do not make such expressions accept-able, only more obvious and more offensive. The quotation marks tell the reader that the writer knows he or she is using the wrong word but is unwilling to find the right word. If for some reason a relatively low word is the right one, use it and don't apologize with quotation marks.

Repetition

Although some repetitions — say, of words like "surely" or "it is noteworthy that" — reveal a tic that ought to be cured by revision, don't be afraid to repeat a word if it is the best word. Notice that in the following paragraph Meyer Schapiro does not hesitate to repeat "Impressionism," "Impressionist," "face," and "portrait" (three times each), and "portraiture" and "photography" (twice each).

> We can follow the decline of portraiture within Impressionism, the art to which van Gogh assumed allegiance. The Impressionist vision of the world could hardly allow the portrait to survive; the human face was subjected to the same evanescent play of color as the sky and sea; for the eyes of the Impressionist it became increasingly a phenomenon of surface, with little or no interior life, at most a charming appearance vested in the quality of a smile or a carefree glance. As the Impressionist painter knew only the passing moment in nature, so he knew only the momentary face, without past or future; and of all its moments, he preferred the most passive and unconcerned, without trace of will or strain, the outdoor, summer holiday face. Modern writers have supposed that it was photography that killed portraiture, as it killed all realism. This view ignores the fact that Impressionism was passionately concerned with appear-ances, and was far more advanced than contemporary photography in catching precisely the elusive qualities of the visible world. If the portrait declines under Impressionism it is not because of the chal-lenge of the photographer, but because of a new conception of the human being. Painted at this time, the portraits of van Gogh are an unexpected revelation. They are even more surprising if we remem-ber that they were produced just as his drawing and color was be-coming freer and more abstract, more independent of nature.
>
> *Vincent van Gogh*
> (New York: Abrams, 1952), pp. 16–17

When you repeat words or phrases, or when you provide clear substitutes (such as "he" for "van Gogh"), you are helping the reader to keep step with your developing thoughts.

An ungrounded fear of repetition often produces a vice known as *elegant variation*. Having mentioned "painters," the writer then speaks of "artists," and then (more desperately) of "men of the brush." This use of synonyms is far worse than repetition; it strikes the reader as silly. When it is not silly, it may be confusing. Consider: "Corot attracted the timid painters of his generation; bolder artists were attracted to Manet." The shift from "painters" to "artists" makes us wonder (and no answer is given) if perhaps Manet's followers — but not Corot's — included etchers, sculptors, and so on.

Be especially careful not to use variations for important critical terms; if, for instance, you are talking about "nonobjective art," don't switch to "abstract art" or "nonrepresentational art" unless you tell the reader why you are switching.

The Sound of Sense, the Sense of Sound

Avoid jingles and other repetitions of sound, as in "The reason the season is autumn . . . ," "Circe certainly . . . ," "Michelangelo's Medici monument. . . ." These irrelevant echoes call undue attention to the words and thus get in the way of the points you are making. But wordplay can be effective when it contributes to meaning. For example, in the sentence "The walls of Xian both defended and defined the city," the echo of "defended" in "defined" nicely emphasizes the unity in this duality.

WRITE EFFECTIVE SENTENCES

Economy

Say everything relevant, but say it in the fewest words possible. The wordy sentence "There are a few vague parts in the picture that give it a mysterious quality" can be written more economically as "A few vaguely defined parts give the picture a mysterious quality." (Nothing has been lost by the deletion of "There are" and

"that.") Even more economical is "A few vague parts add mystery to the picture." The original version says nothing that the second version does not say and says nothing that the third version — nine words against fifteen — does not say. If you find the right nouns and verbs, you can often delete adjectives and adverbs. (Compare "a mysterious quality" with "mystery.")

Something is wrong with a sentence if you can delete words and not sense the loss. A chapter in a recent book begins:

> One of the principle and most persistent sources of error that tends to bedevil a considerable proportion of contemporary analysis is the assumption that the artist's creative process is a wholly conscious and purposive type of activity.

Well, there is something of interest here, but it comes along with a lot of hot air. Why that weaseling ("*tends to* bedevil," "*a considerable* proportion"), and why "type of activity" instead of "activity"? Those spluttering *p's* ("principal and most persistent," "proportion," "process," "purposive") are a giveaway; the writer is gassing, not thinking. Pruned of the verbiage, what he says adds up to this:

> One of the chief errors bedeviling much contemporary criticism is the assumption that the artist's creative process is wholly conscious and purposive.

If the author were to complain that this revision deprives him of his style, might we not fairly reply that what he calls his style is the display of insufficient thinking, a tangle of deadwood?

One especially common source of wordiness is "There is" or "There are" at the beginning of a sentence:

> There is a strong sense of agitation in the drawing.

"There is" coupled with "a sense of" is almost always two steps in the wrong direction. "The drawing is agitated," or "The lines seem agitated," or "The drawing conveys agitation" are all improvements. Of course, we know that the drawing is not really agitated — it is only paper with marks on it — but when we say "The drawing is agitated" we mean, of course, that we *perceive* agitation, even though the drawing is literally inert. "There is a sense of" is unnecessary.

The **passive voice** (wherein the subject is the object of the

action) is a common source of wordiness. In general, do not write "The sculpture was carved by Michelangelo"; instead, write "Michelangelo carved the sculpture." The revision is a third shorter, and it says everything that the longer version says. Another example (from an otherwise excellent catalog of an exhibition of Raphael and his circle):

> Our knowledge of Raphael's later development is not so complete as to enable the possibility that this drawing is by him to be entirely excluded.

Here the passive ("to be entirely excluded") is accompanied by other kinds of wordiness (for instance, instead of writing "this drawing is by him," the author could have written "this drawing is his"), but one might begin by getting rid of the passive:

> Our knowledge of Raphael's later development is not so complete as to enable us to exclude the possibility that the drawing is by him.

Parallels

Use parallels to clarify relationships. Few of us are likely to compose such deathless parallels as "I came, I saw, I conquered," or "of the people, by the people, for the people," but we can see to it that coordinate expressions correspond in their grammatical form. A parallel such as "He liked to draw and to paint" (instead of "He liked drawing and to paint") neatly says what the writer means. Notice the clarity and the power of the following sentence on Henri de Toulouse-Lautrec:

> The works in which he records what he saw and understood contain no hint of comment — no pity, no sentiment, no blame, no innuendo.
>
> Peter and Linda Murray, *A Dictionary of Art and Artists,* 4th ed. (Harmondsworth, England: Penguin, 1976), p. 451

In the following wretched sentence the author seems to think that "people" and "California and Florida" can be coordinate:

> The sedentary Pueblo people of the southwestern states of Arizona and New Mexico were not as severely affected by early Spanish occupation as were California and Florida.

This sort of fuzzy writing is acceptable in a first or even a second draft, but not in a finished essay.

Subordination

First, a word about short sentences. They can, of course, be effective ("Rembrandt died a poor man"), but unless what is being said is especially weighty, short sentences seem childish. They may seem choppy, too, because the periods keep slowing the reader down. Consider these sentences:

> He was assured of government support. He then started to dissociate himself from any political aim. A long struggle with the public began.

There are three ideas here, but they probably are not worth three separate sentences. The choppiness can be reduced by combining them, subordinating some parts to others. In subordinating, make sure that the less important element is subordinate to the more important. In the following example the first clause ("As soon as he was assured of government support"), summarizing the writer's previous sentences, is a subordinate or dependent clause; the new material is made emphatic by being put into two independent clauses:

> As soon as he was assured of government support, he started to dissociate himself from any political aim, and the long struggle with the public began.

The second and third clauses in this sentence, linked by "and," are coordinate — that is, of equal importance.

We have already discussed parallels ("I came, I saw, I conquered") and pointed out that parallel or coordinate elements should appear so in the sentence. The following line gives time and eternity equal treatment: "Time was against him; eternity was for him." The quotation is a **compound sentence** — composed of two or more clauses that can stand as independent sentences but they are connected with a coordinating conjunction such as *and, but, for, nor, yet*; or with a correlative conjunction such as *not only . . . but also*; or with a conjunctive adverb such as *also,* or *however* (these require a semicolon); or with a colon, semicolon, or (rarely)

a comma. But a **complex sentence** (an independent clause and one or more subordinate clauses) does not give equal treatment to each clause; whatever is outside the independent clause is subordinate, less important. Consider this sentence:

> Supported by Theo's money, van Gogh painted at Arles.

The writer puts van Gogh in the independent clause, subordinating the relatively unimportant Theo. Notice, by the way, that emphasis by subordination often works along with emphasis by position. Here the independent clause comes after the subordinate clause; the writer appropriately puts the more important material at the end, that is, in the more emphatic position.

I lad the writer wished to give Theo more prominence, the passage might have run:

> Theo provided money, and van Gogh painted at Arles.

Here Theo (as well as van Gogh) stands in an independent clause, linked to the next clause by "and." The two clauses, and the two people, are now of approximately equal importance.

If the writer had wanted to emphasize Theo and to de-emphasize van Gogh, he might have written:

> While van Gogh painted at Arles, Theo provided the money.

Here van Gogh is reduced to the subordinate clause, and Theo is given the dignity of the only independent clause. (And again notice that the important point is also in the emphatic position, near the end of the sentence. A sentence is likely to sprawl if an independent clause comes first, preceding a long subordinate clause of lesser importance, such as the sentence you are now reading.)

In short, though simple sentences and compound sentences have their place, they make everything of equal importance. Since everything is not of equal importance, you must often write complex and compound-complex sentences, subordinating some ideas to other ideas.

But note: You need not, of course, worry about subtle matters of emphasis while you are drafting your essay. When you re-read the draft, however, you may feel that certain sentences dilute your point, and it is at this stage that you should check to see if you have adequately emphasized what is important.

WRITE UNIFIED AND COHERENT PARAGRAPHS

Unity

A paragraph is one of the major tools for supporting your thesis. If your essay is some five hundred words long — about two double-spaced typewritten pages — you probably will not break it down into more than four or five parts or paragraphs. (But you *should* break your essay down into paragraphs, that is, coherent blocks that give the reader a rest between them. One page of typing is about as long as you can go before the reader needs a slight break.) A paper of five hundred words with a dozen paragraphs is probably faulty not because it has too many ideas but because it has too few *developed* ideas. A short paragraph — especially one consisting of a single sentence — is usually anemic; such a paragraph may be acceptable when it summarizes a highly detailed previous paragraph or group of paragraphs, or when it serves as a transition between two complicated paragraphs, but usually summaries and transitions can begin the next paragraph.

The unifying idea in a paragraph may be explicitly stated in a **topic sentence.** Most commonly, the topic sentence is the first sentence, forecasting what is to come in the rest of the paragraph; or it may be the second sentence, following a transitional sentence. Less commonly, it is the last sentence, summarizing the points that the paragraph's earlier sentences have made. Least commonly — but thoroughly acceptable — the paragraph may have no topic sentence, in which case it has a **topic idea** — an idea that holds the sentences together although it has not been explicitly stated. Whether explicit or implicit, an idea must unite the sentences of the paragraph. If your paragraph has only one or two sentences, the chances are that you have not adequately developed its idea.

A paragraph can make several points, but the points must be related, and the nature of the relationship must be indicated so that there is, in effect, a single unifying point. Here is a satisfactory paragraph about the first examples of Egyptian sculpture in the round. (The figures to which the author refers are not reproduced here.)

Sculpture in the round began with small, crude human figures of mud, clay, and ivory (Fig. 4). The faces are pinched out of the clay until they have a form like the beak of a bird. Arms and legs are long rolls attached to the slender bodies of men, while the hips of the women's figures are enormously exaggerated. A greater variety of attitudes and better workmanship are found in the ivory figurines which sometimes have the eye indicated by the insertion of a bead (Fig. 4). It is the carving of animals, however, such as the ivory hippopotamus from Mesaeed in Fig. 4, or the pottery figure (Fig. 6) which points the way toward the rapid advance which was to be made in the Hierakonpolis ivories and in the small carvings of Dynasty I.

<div style="text-align: right">

William Stevenson Smith, *Ancient Egypt,* 4th
ed. (Boston: Museum of Fine Arts, 1960), p. 20

</div>

Smith is talking about several kinds of objects, but his paragraph is held together by a unifying topic idea: Although most of the early sculpture in the round is crude, some pieces anticipate the later, more skilled work. Notice, by the way, that Smith builds his material to a climax, beginning with the weakest pieces (the human figures) and moving to the best pieces (the animals).

In the next example, from a book on Gothic art, we again get a paragraph that is unified even though it discusses two things.

In Book Five of his treatise *De consideratione,* completed in 1152, St. Bernard of Clairvaux contrasts the unity of the Three Persons of God with other lesser kinds of unity. First in his list is the unity which he calls "collective, as for example when many stones make one heap." And second is the unity which he calls "constitutive, as when many members make one body, or many parts constitute one whole." During the first half of the twelfth century the principle of collective unity as the basis of artistic composition was replaced by the principle of constitutive unity, and as a result the Gothic style was created.

The artistic style which dominated northwest Europe around the year 1100 is represented by a picture in a manuscript of the *Life of St. Aubin* written and illustrated in his monastery at Angers, and by the oldest parts of the priory church of La Charité-sur-Loire. The picture from the Saint's *Life* shows a party of Norman marauders sailing out to sea after their miraculous rout by the saint. The artist achieves compositional unity by the mere accumulation of aggres-

The Normans in Their Boat, shortly before 1100. Illumination on vellum, 11⅝″ × 8″. In a manuscript of the *Life of St. Aubin,* Bibliothèque Nationale, Paris.

Apse of the priory church of La Charité-sur-Loire, consecrated 1107.
Photograph by Martin-Sabon. (Permission © Arch. Phot. Paris/
S.P.A.D.E.M., Paris/ARS, New York)

sively distinct parts, the seven wavy bands which make up the mound of water, the four curved timbers of the hull of the boat, the eleven oval shields, the eleven brutally square faces of the soldiers, their thirty-four vertical spear-shafts, their innumerable domed helmets. The artist's style is vehement, schematic, repetitive, and inhuman. His picture brings vividly to mind St. Bernard's example of collective unity, separate stones placed in a heap. The designer of the choir of La Charité shows this same tendency to think in distinct units which he accumulates but does not integrate, the massive semidome and barrel vault above, the firm chunky columns below, crowned by tight arches. These columns and these arches belong to the same visual world as the Norman pirates' cramped menacing array of spears.

> George Henderson, *Gothic* (Harmondsworth, England: Penguin, 1967), p. 43

The topic sentence at the end of the first paragraph clearly indicates that the one idea in the paragraph is that there are two kinds of unity. The second paragraph is devoted to demonstrating the first kind of unity, the kind that dominated art in northwest Europe during the Romanesque period. It sets forth two examples; again, the two can be set forth in a single paragraph because they are part of a single idea. Notice, by the way, that the final sentence of the paragraph neatly binds together the two examples and summarizes the point. One other comment: If the writer had discussed each example at greater length, he might have given each example in a separate paragraph, in order to give the reader a moment of rest after the first example; but because the second example is set forth briefly, in a single sentence, it shares a paragraph with the first example. In fact, if it were put, unamplified, into a separate paragraph, it would seem skimpy.

The beginning and especially the end of a paragraph are usually the most emphatic parts. A beginning may offer a generalization that the rest of the paragraph supports. Or the early part may offer details, preparing for the generalization in the later part. Or the paragraph may move from cause to effect. Although no rule can cover all paragraphs (except that all must make a point in an orderly way), one can hardly go wrong in making the first sentence either a transition from the previous paragraph or a statement of the paragraph's topic. Here is a sentence that makes a transition and also states the topic:

Not only representational paintings but also abstract paintings have a kind of subject matter.

This sentence gets the reader from subject matter in representational paintings (which the writer has been talking about) to subject matter in abstract paintings (which the writer goes on to talk about). Consider the following two effective paragraphs on Anthony Van Dyck's portrait of Charles I (p. 104).

Rather than begin with an analysis of Van Dyck's finished painting of Charles I, let us consider the problem of representation as it might have been posed in the artist's mind. Charles I saw himself as a cavalier or perfect gentleman, a patron of the arts as well as the embodiment of the state's power and king by divine right. He prided himself more on his dress than on robust and bloody physical feats. Van Dyck had available to him precedents for depicting the ruler on horseback or in the midst of a strenuous hunt, but he set these aside. How then could he show the regal qualities and sportsmanship of a dismounted monarch in a landscape? Compounding the artist's problem was the King's short stature, just about 5 feet, 5 inches. To have placed him next to his horse, scaled accurately, could have presented an ungainly problem of their relative heights. Van Dyck found a solution to this last problem in a painting by Titian, in which a horse stood with neck bowed, a natural gesture that in the presence of the King would have appropriate connotations. Placing the royal pages behind the horse and farther from the viewer than the King reduced their height and obtrusiveness, yet furnished some evidence of the ruler's authority over men. Nature also is made to support and suitably frame the King. Van Dyck stations the monarch on a small rise and paints branches of a tree overhead to resemble a royal canopy. The low horizon line and our point of view, which allows the King to look down on us, subtly increase the King's stature. The restful stance yet inaccessibility of Charles depends largely upon his pose, which is itself a work of art, derived from art, notably that of Rubens. Its casualness is deceptive; while seemingly at rest in an informal moment, the King is every inch the perfect gentleman and chief of state. The cane was a royal prerogative in European courts of the time, and its presence along with the sword symbolized the gentleman-king.

Just as the subtle pose depicts majesty, Van Dyck's color, with its regal silver and gold, does much to impart grandeur to the paint-

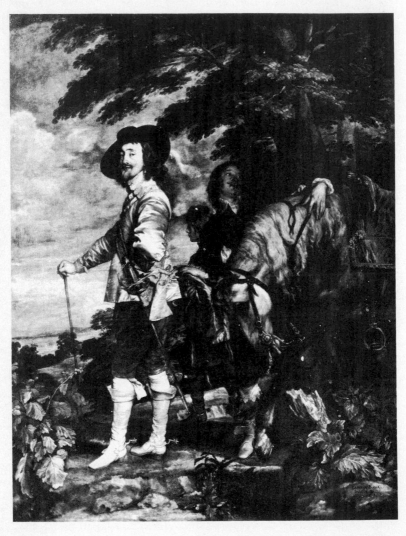

Anthony Van Dyck, *Charles I,* ca. 1635. Oil on canvas, 8'11" × 6'11½".
The Louvre, Paris. (Alinari/Art Resource)

ing and to achieve a sophisticated focus on the King. The red, silver, gold, and black of his costume are the most saturate and intense of the painting's colors and contrast with the darker or less intense coloring of adjacent areas. Largely from Rubens, Van Dyck had learned the painterly tricks by which materials and textures could be vividly simulated, so that the eye moves with pleasure from the silvery silken sheen of the coat to the golden leather sword harness and then on to the coarser surface of the horse, with a similar but darker combination of colors in its coat and mane. Van Dyck's portrait is evidence that, whatever one's sympathy for the message, the artist's virtuosity and aesthetic can still be enjoyed.

 Albert E. Elsen, *Purposes of Art*
 (New York: Holt, Rinehart and Winston, 1972), pp. 221-22

Let's pause to look at the structure of these two paragraphs. The first begins in effect by posing a question (What were the problems Van Dyck faced?) and then goes on to discuss Van Dyck's solutions. This paragraph could have been divided into two, the second beginning "Nature also"; that is, if Elsen had felt that the reader needed a break he could have provided it after the discussion of the King's position and before the discussion of nature and the King's pose within nature. But in fact a reader can take in all of the material without a break, and so the topic idea is "Van Dyck's solutions to the problem." The second paragraph grows nicely out of the first, largely because Elsen begins the second paragraph with a helpful transition, "Just as." The topic idea here is the relevance of the picture's appeal through color; the argument is supported with concrete details, and the paragraph ends by pushing the point a bit further: The colors in the painting not only are relevant to the character portrayed but also have a hold on us.

Coherence

If a paragraph has not only unity but also a structure, then it has coherence, its parts fit together. Make sure that each sentence is properly related to the preceding and the following sentences. Nothing is wrong with such obvious **transitions** as *moreover, however, but, for example, this tendency, in the next chapter,* and so on; but, of course (1) these transitions should not start every sentence (they can be buried thus: "Degas, moreover, . . ."), and (2) they need not

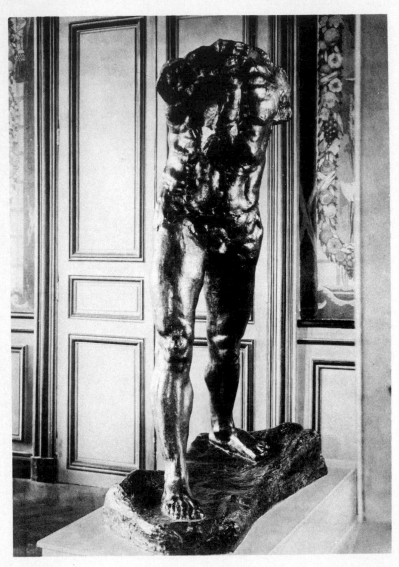

Auguste Rodin, *L'Homme Qui Marche,* 1900. Bronze, 7′11¾″. Rodin Museum, Paris. (Art Resource, New York)

appear anywhere in the sentence. The point is not that transitions must be explicit but that the argument must proceed clearly. The gist of a paragraph might run thus: "Speaking broadly, there were in the Renaissance two traditions of portraiture. . . . The first. . . . The second. . . . The chief difference. . . . But both traditions. . . ."

Consider the following lucid paragraph from an essay on Auguste Rodin's *Walking Man*:

> *L'Homme qui marche* is not really walking. He is staking his claim on as much ground as his great wheeling stride will encompass. Though his body's axis leans forward, his rearward left heel refuses to lift. In fact, to hold both feet down on the ground, Rodin made the left thigh (measured from groin to patella) one-fifth as long again as its right counterpart.
>
> Leo Steinberg, *Other Criteria*
> (New York: Oxford University Press, 1972), p. 349

Notice how easily we move through the paragraph: The figure "is not. . . . He is. . . . Though. . . . In fact. . . ." These little words take us neatly from point to point.

Introductory Paragraphs

Vasari, in *Lives of the Painters,* tells us that Fra Angelico "would never take his pencil in his hand till he had first uttered a prayer." One can easily understand. Beginning a long poem, Lord Byron aptly wrote, "Nothing so difficult as a beginning." Of course, your job is made easier if your instructor has told you to begin your analysis with some basic facts: identification of the object (title, museum, museum number), subject matter (e.g., mythological, biblical, portrait), and technical information (material, size, condition). Even if your instructor has not told you to begin thus, you may find it helpful to start along these lines. The mere act of writing *anything* will probably help you to get going.

Still, almost all writers — professionals as well as amateurs — find that the beginning paragraphs of their drafts are false starts. In your finished paper the opening cannot be mere throat clearing. It should be interesting and informative. Don't take your title ("Space in Manet's *A Bar at the Folies-Bergère*") and merely paraphrase it in

your first sentence: "This essay will study space in Manet's *A Bar at the Folies-Bergère*." There is no information about the topic here, at least none beyond what the title already gave, and there is no information about you either, that is, no sense of your response to the topic, such as might be present in, say, "The space in *A Bar at the Folies-Bergère* is puzzling; one at first wonders where the viewer is supposed to be standing." But in your effort to find your voice and to say something interesting, don't yield to irrelevancy or to grandiloquence ("Space, Shakespeare says. . . ."). One surefire method is this: Suggest your thesis in your opening paragraph, moving from a generalization ("the space in the picture is puzzling") to some supporting details ("where is the man standing, whose reflection we see in the upper right?"). Such an introduction quickly and effectively gets down to business; especially in a short paper there is no need (or room) for a long-winded introduction.

Notice in the following example, the opening paragraph in an essay on Buddhist art in Japan, how the writer moves from a "baffling diversity" to "one major thread of continuity."

> Amid the often baffling diversity which appears in so much of the history of Japanese art, one major thread of continuity may be traced throughout the evolution of religious painting and sculpture. This tradition was based on the great international style of East Asian Buddhist imagery, which reached its maturity during the early eighth century in T'ang China and remained a strong influence in Japan through the thirteenth century.
>
> John Rosenfield, *Japanese Arts of the Heian Period: 794-1185* (New York: Asia Society, 1967), p. 23

Similarly, in the next example we move from a general comment about skin-clinging garments to an assertion of the thesis (the convention is exaggerated in English Neoclassical art), and this thesis is then supported with concrete details.

> The pictorial and sculptural custom of clothing the nude in skin-clinging dress has many and often-copied Classical precedents, but the erotic emphasis of this convention seems exaggerated in English art of the Neoclassic period more than at other times and places. The shadowy meeting of thighs, the smooth domes of bosom and backside, are all insisted on more pruriently through the lines of the dress than they were by contemporary French artists or by Botticelli and

Mantegna and Desiderio da Settignano, who were attempting the same thing in the Renaissance — or, indeed, than by the Greek sculptors. The popular artists Rowlandson and Gillray naturally show this impulse most blatantly in erotic cartoons and satirical illustrations, in which women have enormous bubbly hemispheres fore and aft, outlined by the emphatically sketched lines of their dress.

Anne Hollander, *Seeing Through Clothes*
(New York: Viking, 1978), p. 118

Concluding Paragraphs

The preceding discussion of opening paragraphs quoted Lord Byron: "Nothing so difficult as a beginning." But he went on to add, "Unless perhaps the end."

In conclusions, as in introductions, try to say something interesting. It is not of the slightest interest to say "Thus we see . . . [here the writer echoes the title and the first paragraph] " There is some justification for a summary at the end of a long paper because the reader may have half forgotten some of the ideas presented thirty pages earlier, but a paper that can easily be held in the mind needs something different. A good concluding paragraph does more than provide an echo of what the writer has already said. It rounds out the previous discussion, normally with a few sentences that summarize (without the obviousness of "We may now summarize"), but it also may draw an inference that has not previously been expressed, thus setting the previous material in a fresh perspective. A good concluding paragraph closes the issue while enriching it.

Notice how the example that follows wraps things up and, at the same time, opens outward by suggesting a larger frame of reference. The writer is ending his discussion of Bernini's piazza of St. Peter's.

As happens with most new and vital ideas, after initial sharp attacks the colonnades became of immense consequence for the further history of architecture. Examples of their influence from Naples to Greenwich and Leningrad need not be enumerated. The aftermath can be followed up for more than two and a half centuries.

Rudolf Wittkower, *Art and Architecture
in Italy: 1600–1750,* 3d ed. (Harmondsworth,
England: Penguin, 1973), p. 196

Pretty much the same technique is used at the end of Elsen's second paragraph on Van Dyck's *Charles I* (p. 105), where he moves from his detailed discussion of the picture to the assertion that the picture continues to attract us.

Finally, don't feel that you must always offer a conclusion in your last paragraph. When you have finished your analysis, it may be enough to stop — especially if your paper is fairly short, let's say fewer than five pages. If, for example, you have throughout your paper argued that a certain Japanese print shows a Western influence in its treatment of space, you need scarcely reaffirm the overall thesis in your last paragraph. Probably it will be conclusion enough if you just offer your final evidence, in a well-written sentence, and then stop.

6
Manuscript Form

BASIC MANUSCRIPT FORM

Much of what follows is nothing more than common sense. Unless your instructor specifies something different, you can adopt these principles as a guide.

1. Use 8½-by-11-inch paper of good weight. Do not use paper torn out of a spiral notebook; ragged edges distract a reader.

2. Write on one side of the page only. If you typewrite, double-space, typing with a reasonably fresh ribbon. If you submit a handwritten copy, use lined paper and write, in black or dark blue ink, on every other line if the lines are closely spaced. A word to the wise: Instructors strongly prefer typed papers.

3. Put your name and class or course number in the upper right-hand corner of the first page. It is a good idea to put your name in the upper right corner of each subsequent page, so the instructor can easily reassemble your essay if somehow a page gets detached and mixed with other papers.

4. Center the title of your essay about two inches from the top of the first page. Capitalize the first letter of the first and last words of your title, the first word after a semicolon or colon if you use either one, and the first letter of all the other words except articles (*a, an, the*), conjunctions (*and, but, or*, etc.), and prepositions (*about, in, on, of, with,* etc.), thus:

The Renaissance and Modern Sources of Manet's <u>Olympia</u>

Notice that your title is neither underlined nor enclosed in quotation marks, though of course if, as here, it includes the title of a work of art (other than architecture), that title is underlined to indicate italics.

5. Begin the essay an inch or two below the title. If your instructor prefers a title page, do not number it, but begin the essay on the next page.

6. Leave an adequate margin — an inch or an inch and a half — at top, bottom, and sides, so that your instructor can annotate the paper.

7. Number the pages consecutively, using arabic numerals in the upper right-hand corner. If you give the title on a separate page, do not number that page; the page that follows it is page 1.

8. Indent the first word of each paragraph five spaces from the left margin.

9. When you refer to a work illustrated in your essay, include helpful identifying details in parentheses, thus:

Vermeer's The Studio (Vienna, Kuntshistorisches Museum, Figure 6) is now widely agreed to be an allegorical painting.

But if in the course of the essay itself you have already mentioned where the picture is, do not repeat such information in the parenthetic material.

10. If possible, insert photocopies of the illustrations at the appropriate places in the paper, unless your instructor has told you to put all of the illustrations at the rear of the paper. Number the illustrations and give captions that include, if possible, artist (or, for anonymous works, the culture), title (underlined), date, medium, dimensions (height precedes width), and present location. Examples:

Figure 1. Japanese, Flying Angel, second half of the eleventh century. Wood with traces of gesso and gold, 33 ½'' x 15''. Museum of Fine Arts, Boston.

```
Figure 2. Diego Velázquez, Venus and Cupid, ca. 1644-
48. Oil on canvas, 3' 11 ⅞'' x 5' 9 ¼''. National
Gallery, London.
```

Note that in the second example the abbreviation ca. stands for *circa,* Latin for "about."

If there is some uncertainty about whether or not the artist created the work, precede the artist's name with *Attributed to.* If the artist had an active studio, and there is uncertainty about the degree of the artist's involvement in the work, put *Studio of* before the artist's name.

Three other points about captions for illustrations:

1. if you use the abbreviations B.C. or A.D., do not put a space between the letters;
2. B.C. follows a numeral (7 B.C.) but A.D. precedes a numeral (A.D. 10);
3. some instructors may ask you to cite also your source for the illustration, thus:

```
Figure 3. Japanese, Head of a Monk's Staff, late
twelfth century. Bronze, 9 ¼''. Peabody Museum,
Salem, Massachusetts. Illustrated in John Rosenfield,
Japanese Arts of the Heian Period: 794-1185 (New York:
Asia Society, 1967), p. 91
```

If, in your source, the pages with plates are unnumbered, give the plate number where you would ordinarily give the page number.

11. If a reproduction is not available, be sure when you refer to a work to tell your reader where the work is. If it is in a museum, give the acquisition number, if possible. This information is important for works that are not otherwise immediately recognizable. A reader needs to be told more than that a Japanese tea bowl is in the Freer Gallery. The Freer has hundreds of bowls, and, in the absence of an illustration, only the acquisition number will enable a visitor to locate the bowl you are writing about.

12. If you haven't made a carbon copy, make a photocopy of your essay, or print a second copy from a word processor, so that if the instructor misplaces the original you need not write the paper again.

13. Fasten the pages of your paper with a staple or paper clip in the upper left-hand corner. (Find out which sort of fastener your instructor prefers.) Stiff binders are unnecessary; indeed they are a nuisance to the instructor, for they add bulk and they make it awkward to write annotations.

CORRECTIONS IN THE FINAL COPY

Your extensive revisions should have been made in your drafts, but minor last-minute revisions may be made on the finished copy. In proofreading you may catch some typographical errors, and you may notice some minor weaknesses. For example, in the final copy you may notice an error in agreement between subject and verb: "The weaknesses in the draftsmanship is evident." The subject is "weaknesses" (not "draftsmanship") and so the verb should be "are," not "is." You need not retype the page, or even erase. You can make corrections with the following proofreader's symbols.

Changes in wording may be made by crossing through words and rewriting just above them, either on the typewriter or by hand in pen:

> The weaknesses in the draftsmanship ~~is~~ *are* evident.

Additions should be made above the line, with a caret (^) below the line at the appropriate place:

> The weaknesses in the draftsmanship∧*are* evident.

Transpositions of letters may be made thus:

> The weaknesses in ⌐h⌐t⌐e draftsmanship are evident.

Deletions are indicated by a horizontal line through the word or words to be deleted. Delete a single letter by drawing a vertical or diagonal line through it.

> The weaknesses in ~~in~~ the draftsmanship/ are evident.

Separation of words accidentally run together is indicated by a vertical line, *closure* by a curved line connecting the things to be closed up:

> The weaknessesin the dᴖraftsmanship are evident.

Paragraphing may be indicated by the symbol ⁋ before the word that is to begin the new paragraph.

> The weaknesses are evident. ⁋ For instance, the
> draftsmanship is hesitant, and the use of color
> is. . . .

QUOTATIONS AND QUOTATION MARKS

If you are writing a research paper, you will, of course, include quotations, almost surely from scholars who have worked on the topic, and possibly also from documents such as letters or treatises written by the artist or by the artist's contemporaries. But even in a short analysis, based chiefly on looking steadily at the object, you may want to quote a source or two — for example, your textbook. The following guidelines tell you how to give quotations and how to cite your sources — but remember, a paper is not a bundle of quotations.

1. Distinguish between short and long quotations, and treat each appropriately. Short quotations (usually defined as fewer than five lines of prose) are enclosed within quotation marks and run into the text (rather than set off, without quotation marks).

> Michael Levey points out that ''Alexander singled out
> Lysippus to be his favorite sculptor, because he liked
> the character given him in Lysippus' busts.'' In mak-
> ing this point, Levey is not taking the familiar view
> that. . . .

Material that is set off (usually five or more lines of typewritten prose) is *not* enclosed within quotation marks. To set it off, triple-space before and after the quotation and single-space the quotation, indenting five spaces — ten spaces for the first line if the quotation begins with the opening of a paragraph. (Note: The suggestion that you single-space longer quotations seems reasonable but is at odds with various manuals that tell how to prepare a manuscript for publication. Such manuals usually say that material that is set off should be indented ten spaces and double-spaced. Find out if your instructor has a preference.)

Be sparing in your use of quotations. Use quotations as evidence, not as padding. If the exact wording of the original is crucial, or especially effective, quote it directly, but if it is not, don't bore the reader with material that can be effectively reduced either by summarizing or by cutting. If you cut, indicate ellipses as explained later, under point 3.

2. An embedded quotation (i.e., a quotation embedded into a sentence of your own) must fit grammatically into the sentence of which it is a part. For example, suppose you want to use Zadkine's comment, "I do not believe that art must develop on national lines."

Incorrect

```
Zadkine says that he ''do not believe that art must
develop on national lines.''
```

Correct

```
Zadkine says that he does ''not believe that art must
develop on national lines.''
```

Correct

```
Zadkine says, ''I do not believe that art must develop
on national lines.''
```

Don't try to introduce a long quotation (say, more than a complete sentence) into the middle of one of your own sentences. It is almost impossible for the reader to come out of the quotation and to pick

up the thread of your own sentence. It is better to lead into the long quotation with "Jones says . . ." and then, after the quotation, to begin a new sentence of your own.

 3. The quotation must be exact. Any material that you add must be in square brackets (not parentheses), thus:

> Pissarro, in a letter, expressed his belief that ''the Japanese practiced this art [of using color to express ideas] as did the Chinese.''

If you wish to omit material from within a quotation, indicate the ellipsis by three spaced periods. If a sentence ends in an omission, add a closed-up period and then three spaced periods to indicate the omission. The following example is based on a quotation from the sentences immediately before this one:

> The manual says that ''if you . . . omit material from within a quotation, [you must] indicate the ellipsis. . . . If a sentence ends in an omission, add a closed-up period and then three periods. . . .''

Notice that although material preceded "if you," periods are not needed to indicate the omission because "if you" began a sentence in the original. (Notice, too, that although in the original *if* was capitalized, in the quotation it is reduced to lowercase in order to fit into the sentence grammatically.) Customarily initial and terminal omissions are indicated only when they are part of the sentence you are quoting. Even such omissions need not be indicated when the quoted material is obviously incomplete — when, for instance, it is a word or phrase.

 4. Identify the speaker or writer of the quotation, so that readers are not left with a sense of uncertainty. Usually this identification precedes the quoted material (e.g., you write something like "Kenneth Clark says" or "Kenneth Clark long ago pointed out"), in accordance with the principle of letting readers know where they are going. But occasionally the identification may follow the quotation, especially if it will prove something of a pleasant surprise. For example, in a discussion of Jackson Pollock's art, you

might quote a hostile comment on one of the paintings and then reveal that Pollock himself was the speaker. (Further suggestions about leading into quotations are given on page 159.)

5. Commas and periods go inside the quotation marks; semicolons and colons go outside. Question marks, exclamation points, and dashes go inside if they are part of the quotation, outside if they are your own.

6. Use *single* quotation marks for material contained within a quotation that itself is within quotation marks. In the following example, a student quotes William Jordy (the quotation from Jordy is enclosed within double quotation marks), who himself quoted Frank Lloyd Wright (the quotation within Jordy's quotation is enclosed within single quotation marks):

```
William H. Jordy believes that to appreciate Wright's
Guggenheim Museum one must climb up it, but he recog-
nizes that ''Wright . . . recommended that one take
the elevator and circle downward. 'The elevator is
doing the lifting,' as he put it, 'the visitor the
drifting from alcove to alcove.' ''
```

7. Use quotation marks around titles of short works, that is, for titles of chapters in books and for stories, essays, short poems, songs, lectures, and speeches. Titles of unpublished works, even book-length dissertations, are also enclosed in quotation marks. But underline — to indicate *italics* — titles of pamphlets, periodicals, and books. Underline also titles of films, radio and television programs, ballets and operas, and works of art except architecture. Thus: Michelangelo's *David,* Picasso's *Guernica,* Frank Lloyd Wright's Guggenheim Museum.

Exception: Titles of sacred writings (e.g., the Old Testament, the Bible, Genesis, Acts, the Gospels, the Koran) are neither underlined nor enclosed within quotation marks. To cite a book of the Bible with chapter and verse, give the name of the book, then a space, then a small roman numeral for the chapter, a colon, and an arabic numeral (*not* preceded by a space) for the verse, thus: Exodus xx: 14-15. Standard abbreviations for the books of the Bible (e.g.,

Chron.) are permissible in footnotes and in parenthetic citations
within the text.

ACKNOWLEDGING SOURCES

Borrowing without Plagiarizing

You must acknowledge your indebtedness for material when
(1) you quote directly from a work; (2) you paraphrase or sum-
marize someone's words (the words of your paraphrase or sum-
mary are your own, but the points are not); or (3) you appropriate
an idea that is not common knowledge.

Let's suppose you are going to make use of Ralph Linton's
comment on definitions of primitive art.

> The term "primitive art" has come to be used with at least three
> distinct meanings. First and most legitimate is its use with reference
> to the early stages in the development of a particular art, as when
> one speaks of the Italian primitives. Second is its use to designate
> works of art executed by persons who have not had formal training
> in our own art techniques and aesthetic canons. Third is its applica-
> tion to the art works of all but a small group of societies which we
> have chosen to call civilized. The present discussion will deal only
> with the last.
>
> Ralph Linton, Preface to Eliot Elisofon,
> *The Sculpture of Africa* (New York: Praeger, 1958), p. 9

1. *Acknowledging a direct quotation.* You may want to use some
or all of Linton's words, in which case you will write something
like this:

> As Ralph Linton says, ''The term 'primitive art'
> has come to be used with at least three distinct
> meanings. First and most legitimate is its use with
> reference to the early stages in the development of a
> particular art, as when one speaks of the Italian
> primitives.''[1]

Notice that the digit, indicating a footnote, is raised, and that it
follows the period and the quotation marks. (The form of footnotes
is specified on pp. 123–31.) And, of course, in a relatively informal
paper it may be enough merely to mention, in the body of the
paper, the author, title, and page number, without using a footnote
specifying place of publication, publisher, and date. The point here
is not that you must use detailed footnotes but that you must give
credit. Not to give credit is to plagiarize, which is a serious breach
of the rules governing academic work.

 2. *Acknowledging a paraphrase or summary.* Summaries (abridg-
ments) are usually superior to paraphrases (rewordings, of approx-
imately the same length as the original) because summaries are
briefer; but occasionally you may find that you cannot greatly
abridge a passage in your source and yet don't want to quote it
word for word — perhaps because it is too technical or because it
is poorly written. Even though you are changing some or all of the
words, you must give credit to the source because the idea is not
yours. Here is an example of a summary:

> Ralph Linton, in his Preface to Eliot Elisofon's
> Sculpture of Africa, suggests that there are at least
> three common but distinct meanings of the term
> ''primitive art'': the early stages of a particular
> art; the art of untrained artists; and the art of so-
> cieties that we consider uncivilized.

Not to give credit to Linton is to plagiarize, even though the words
are yours. The offense is just as serious as not acknowledging a
direct quotation. And, of course, if you say something like this,
and do not give credit, you are also plagiarizing:

> ''Primitive art'' is used in three different sen-
> ses. First and most reasonable is the use of the word
> to refer to the early years of a certain art.

It is pointless to offer this sort of rewording: If there is a point, it
is to conceal the source and to take credit for thinking that is not
your own.

3. *Acknowledging an idea.* Let us say that you have read an essay in which Seymour Slive argues that many Dutch still lifes have a moral significance. If this strikes you as a new idea and you adopt it in an essay — even though you set it forth entirely in your own words and with examples not offered by Slive — you should acknowledge your debt to Slive. Not to acknowledge such borrowing is plagiarism. Your readers will not think the less of you for naming your source; rather, they will be grateful to you for telling them about an interesting writer.

In short, acknowledge your source (1) if you quote directly, and put the quoted words in quotation marks; (2) if you summarize or paraphrase someone's material, even though not one word of your source is retained; and (3) if you borrow a distinctive idea even though the words and the concrete application are your own.

Fair Use of Common Knowledge

If in doubt as to whether or not to give credit (either in a footnote or merely in an introductory phrase such as "Ralph Linton says"), give credit. But as you begin to read widely in your field or subject, you will develop a sense of what is considered common knowledge. Unsurprising definitions in a dictionary can be considered common knowledge, and so there is no need to say "According to Webster, a mural is a picture or decoration applied to a wall or ceiling." (That's weak in three ways: It's unnecessary, it's uninteresting, and it's unclear, since "Webster" appears in the titles of several dictionaries, some good and some bad.)

Similarly, the date of Picasso's death can be considered common knowledge. Few can give it when asked, but it can be found in many sources, and no one need get the credit for providing you with the date. Again, if you simply *know,* from your reading of Freud, that Freud was interested in art, you need not cite a specific source for an assertion to that effect, but if you know only because some commentator on Freud said so, and you have no idea whether the fact is well known or not, you should give credit to the source that gave you the information. Not to give credit — for ideas as well as for quoted words — is to plagiarize.

"But How Else Can I Put It?"

If you have just learned — say, from an encyclopedia — something that you sense is common knowledge, you may wonder, How can I change into my own words the simple, clear words that this source uses in setting forth this simple fact? For example, if before writing about Rosa Bonheur's painting of Buffalo Bill (he took his Wild West show to France), you look him up in the *Encyclopedia Britannica,* you will find this statement about Buffalo Bill (William F. Cody): "In 1883 Cody organized his first Wild West exhibition." You cannot use this statement as your own, word for word, without feeling uneasy. But to put in quotation marks such a routine statement of what can be considered common knowledge, and to cite a source for it, seems pretentious. After all, the *Encyclopaedia Americana* says much the same thing in the same routine way: "In 1883, . . . Cody organized Buffalo Bill's Wild West." It may be that the word "organized" is simply the most obvious and the best word, and perhaps you will end up using it. Certainly to change "Cody organized" into "Cody presided over the organization of" or "Cody assembled" or some such thing, in an effort to avoid plagiarizing, would be to make a change for the worse and still to be guilty of plagiarism. But you won't get yourself into this mess of wondering whether to change clear, simple wording into awkward wording if in the first place, when you take notes, you summarize your sources, thus: "1883: organized Wild West," or "first Wild West: 1883." Later (even if only thirty minutes later), when drafting your paper, if you turn this nugget — probably combined with others — into the best sentence you can, you will not be in danger of plagiarizing, even if the word "organized" turns up in your sentence.

Notice that *taking notes* is part of the trick; this is not the same thing as copying or photocopying. Photocopying machines are great conveniences but they also make it easy for us not to think; we later may confuse a photocopy of an article with a thoughtful response to an article. The copy is at hand, a few words underlined, and we use the underlined material with the mistaken belief that we have absorbed it.

If you take notes thoughtfully, rather than make copies mindlessly, you will probably be safe. Of course, you may want to say somewhere that all your facts are drawn from such-and-such a

source, but you offer this statement not to avoid charges of plagiarism but for three other reasons: to add authority to your paper, to give respectful credit to those who have helped you, and to protect yourself in case your source contains errors of fact.

FOOTNOTES AND ENDNOTES

Kinds of Notes

In speaking of kinds of notes, this paragraph is not distinguishing between footnotes, which appear at the bottom of the page, and endnotes, which appear at the end of the essay; for simplicity *footnote* will cover both terms. Rather, a distinction is being made between (1) notes that give the sources of quotations, facts, and opinions used and (2) notes that give additional comment that would interrupt the flow of the argument in the body of the paper.

This second type perhaps requires a comment. You may wish to indicate that you are familiar with an opinion contrary to the one you are offering, but you may not wish to digress upon it during the course of your argument. A footnote lets you refer to it and indicate why you are not considering it. Or a footnote may contain full statistical data that support your point but that would seem unnecessarily detailed and even tedious in the body of the paper. This kind of footnote, giving additional commentary, may have its place in research papers and senior theses, but even in such essays it should be used sparingly, and it rarely has a place in a short analytic essay. There are times when supporting details may be appropriately relegated to a footnote, but if the thing is worth saying, it is usually worth saying in the body of the paper. Don't get into the habit of affixing either trivia or miniature essays to the bottom of each page of an essay.

Footnote Numbers and Positions

Number the notes consecutively through the essay or chapter. Although some instructors allow students to group all the notes at the rear of the essay, most instructors — and surely all readers — believe that the best place for a footnote is at the foot of the appropriate page. If you type all your footnotes in your draft, when

typing your final copy you can easily gauge how much space the footnotes for any given page will require.

Footnote Style

To indicate that there is a footnote, put a raised arabic numeral (without a period and without parentheses) after the final punctuation of the sentence, unless clarity requires it earlier. (In a sentence about Claude Monet, Camille Pissarro, and Alfred Sisley you may need a footnote for each and a corresponding numeral after each name instead of one numeral at the end of the sentence, but usually a single reference at the end will do. The single footnote might explain that Monet says such and such in a book entitled ————, Pissarro says such and such in a book entitled ————, and Sisley says such and such in a book entitled ————.

At the bottom of the page double-space twice (i.e., skip three lines) before giving the first footnote. Then indent five spaces, raise the typewriter carriage half a line, and type the arabic numeral (without a period). Lower the carriage to the regular position, skip one space, and type the footnote, single-spacing it. (Some manuals suggest double-spacing footnotes that run more than one line. Ask your instructors if they have a preference.) If the note runs more than one line, the subsequent lines are flush with the left margin, but each new note begins with an indentation of five spaces. Each note begins with an indented, raised numeral, then a capital letter, and ends with a period or other terminal punctuation. Double-space between footnotes.

FIRST REFERENCE TO A BOOK

Here is a typical first reference to a book:★

[1]Michael Levey, <u>Painting at a Court</u> (New York: New York University Press, 1971), p. 134.

★Different publishers, and different periodicals, have different styles. Some, for example, do not require that the name of the publisher of a book be given in the footnote. The style discussed here, however, is the style most widely used.

Notice that you give the author's name as it appears on the title page, *first name first*. You need not give the subtitle, but if you do give it, put a colon between the title and the subtitle and underline the subtitle. The name of the city (without the state or country) is usually enough; but if the city is not well known, or may be confused with another city of the same name (Cambridge, England, and Cambridge, Massachusetts), the state or country is added. The name of the publisher (here New York University Press) may be shortened. (Thus, Little, Brown and Company may be shortened to Little, Brown.) If the date is not given, in place of it put n.d. The conventional abbreviation for page is "p." and for pages is "pp." (*not* "pg." and "pgs."). If you give the author's name in the body of the page — for example, in such a phrase as "Levey says that Rubens" — do not repeat the name in the footnote. Merely begin with the title:

[1] Painting at Court (New York: New York University Press, 1971), p. 134.

But do not get carried away by the principle of not repeating in the note any material already given in the body of the paper. If the author and the title are given, convention nevertheless requires you to repeat the title — though not the author's name — in the first note citing the source.

For a book in one volume, by one author, revised edition:

[2] Rudolf Wittkower, Art and Architecture in Italy, 1600–1750, 3d ed. rev. (Harmondsworth, England: Penguin, 1973), p. 187.

For a book in one volume, by one author, later reprint:

[3] Erwin Panofsky, Studies in Iconology (1939; rpt. New York: Harper & Row, 1962), pp. 126–27.

For a book in more than one volume (notice that the volume number is given in roman numerals, the page number in arabic numerals, and abbreviations such as "vol." and "p." are *not* used):

[4]Ronald Paulson, <u>Hogarth: His Life, Art, and Times</u> (New Haven, Conn.: Yale University Press, 1971), II, 161.

For a book by more than one author (if there are more than three authors, give the full name of the first author and add *et al.*, the Latin abbreviation for "and others"):

[5]John M. Rosenfield and Shujiro Shimada, <u>Traditions of Japanese Art</u> (Cambridge, Mass.: Fogg Museum, 1970), pp. 280–81.

The name of the second author, like that of the first, is given *first name first*.

For an edited or translated book:

[6]<u>The Letters of Peter Paul Rubens</u>, trans. and ed. Ruth Magurn (Cambridge, Mass.: Harvard University Press, 1955), p. 238.

[7]Dietrich Seckel, <u>The Art of Buddhism</u>, trans. Ann E. Keep (New York: Crown, 1964), p. 208.

[8]Charles Pellet, ''Jewelers with Words,'' in <u>Islam and the Arab World</u>, ed. Bernard Lewis (New York: Knopf, 1976), p. 151.

As note 8 indicates, when you are quoting from an essay in an edited book, you begin with the essayist (first name first) and the essay, then go on to give the title of the book and the name of the editor, first name first.

For an article in an encyclopedia, publisher and place of publication need not be given. If the article is signed, begin with the author's name (first name first); if it is unsigned, simply begin with the title of the article, in quotation marks. The first example is for a signed article on Picasso:

[9]Thomas M. Messer, ''Picasso, Pablo,'' <u>Encyclopedia Americana</u>, 1979, XXII, 67.

Some manuals say that references to alphabetically arranged articles (signed or unsigned) need not include the volume and page number, but if you do include them, as here, use roman numerals for the volume (but do *not* write "vol.") and arabic numerals for the page (but do *not* write "p.").

The most recent edition of the *Encyclopaedia Britannica* comprises three groups of books, called *Propaedia, Micropaedia,* and *Macropaedia,* so you must specify which of the three groups you are referring to. The following example cites an unsigned article on Picasso:

10''Picasso, Pablo (Ruiz y),'' Encyclopaedia Britannica: Micropaedia, 1974, VII, 987.

REFERENCES TO INTRODUCTIONS AND TO REPRINTED ESSAYS

You may need to footnote a quotation from someone's introduction (say, Kenneth Clark's) to someone else's book (say, James Hall's). If, for example, in your text you say, "As Kenneth Clark points out," the footnote will look like this:

11Introduction to James Hall, Dictionary of Subjects and Symbols in Art, 2d od. (New York: Harper & Row, 1979), p viii.

If you want to quote from, say, an essay or an extract from a book that has been reprinted in a book of essays, begin with the writer's name (if you have not given it in your lead-in), then give the title of the essay or original book, then, if possible, the place where this material originally appeared (you can usually find this information on the acknowledgment page of the book in hand or on the first page of the reprinted material), then the name of the title of the book you have in hand, and then the editor, place of publication, publisher, date, and page. The monstrous but accurate footnote might run like this:

12Albert E. Elsen, Rodin (New York: Museum of Modern Art, 1963); in Readings in Art History, 2d ed., ed. Harold Spencer (New York: Scribner's, 1976), II, 291.

You have read a selection from Elsen's *Rodin,* but you did not actually read it in Elsen's book; rather, you read it in the second volume of Spencer's anthology entitled *Readings in Art History.* You learned the name of Elsen's book, and the data about publication, from Spencer, so you print them, but your page reference is of course to the book that you are holding in your hand, page 291 in the second volume of Spencer's collection.

FIRST REFERENCE TO A JOURNAL

Footnote 13 is for a journal (here, volume 29) paginated consecutively throughout the year; footnote 14 is for a journal that paginates each issue separately. For a journal paginated separately you must list the issue number or month or week or day as well as the year because if it is, for example, a monthly, there will be twelve page 10's in any given year. Current practice favors omitting the volume number for popular weeklies (see footnote 15) and for newspapers, in which case the full date is given without parentheses.

13 Anne H. van Buren, ''Madame Cézanne's Fashions and the Dates of Her Portraits,'' Art Quarterly, 29 (1966), 119.

14 Linda Nochlin, ''Why Have There Been No Great Women Artists?'' Art News 69 (January 1971), 38.

15 Henry Fairlie, ''The Real Life of Women,'' New Republic, Aug. 26, 1978, p. 18.

The author's name and the title of the article are given as they appear in the journal (*first name first*), the title of the article in quotation marks, and the title of the journal underlined (to indicate italics). Until recently the volume number, before the date, was given with capital roman numerals, but current practice uses arabic numerals for both the volume and the page or pages. Notice that when a volume number is given, as in notes 13 and 14, the page number is *not* preceded by "p." or "pp."

The sample notes cite the specific page that the student is drawing on. If the article as a whole is being cited, instead of, say, page 119, we would get 117-22.

If a book review has a title, the review may be treated as an article. If, however, the title is merely that of the book reviewed, or even if the review has a title but for clarity you wish to indicate that it is a review, the following form is commonly used:

> [16]Pepe Karmel, review of Calvin Tomkins, Off the Wall: Robert Rauschenberg and the Art World of Our Time (Garden City, N.Y.: Doubleday, 1980), New Republic, June 21, 1980, p. 38.

FIRST REFERENCE TO A NEWSPAPER

The first example is for a *signed article,* the second for an unsigned one:

> [17]Bertha Brody, ''Illegal Immigrant Sculptor Allowed to Stay,'' New York Times, July 4, 1980, Sec. B, p. 12, col. 2.

> [18]''Portraits Stolen Again,'' Washington Post, June 30, 1980, p. 7, col. 3.

UNPAGINATED MATERIAL

If a pamphlet is unpaginated, simply put "unpaginated" where you would ordinarily put the page number. If plates in an article or book are unpaginated, put "Plate 1" (or whatever the number) where you would ordinarily put the page number.

SECONDHAND REFERENCES

If you are quoting from, say, Frank Lloyd Wright, but you have not derived the quotation directly from Wright but from a book or article that quotes him, your footnote should indicate both the original source, if possible (i.e., not only Wright's name but his book, place of publication, etc.), and then full information about the place where you have found the material that you are using.

> [19]Frank Lloyd Wright, The Solomon R. Guggenheim Museum (New York: Museum of Modern Art, 1960), p. 20; quoted in William H. Jordy, American Buildings and Their Architects (Garden City, N.Y.: Anchor, 1976), IV, 348.

If Jordy had merely cited Wright's name, without any further bibliographic information, of course, you would be able to give only Wright's name and then the details about Jordy's book.

SUBSEQUENT REFERENCES

If you quote a second or third or fourth time from a work, use a short form in your footnote. The most versatile short form is simply the author's last name and the page number, thus:

[20]Levey, p. 155.

You can even dispense with the author's name if you have mentioned it in the sentence to which the footnote is keyed. That is, if you have said "Panofsky goes on to say," the footnote need only be

[21]P. 108.

If, however, you have made reference to more than one work by the author, you must indicate by a short title which work you are referring to, thus:

[22]Panofsky, Studies, p. 108.

Or if your sentence mentions that you are quoting Panofsky, the footnote may be

[23]Studies, p. 108.

If you have said something like "Panofsky, in *Studies in Iconology*," the reference may be merely

[24]P. 108.

In short, a subsequent reference should be as brief as clarity allows. The form "ibid." (for *ibidem*, "in the same place"), indicating that the material being footnoted comes from the same place as the material of the previous footnote, is no longer preferred for second references. "Op cit." (for *opere citato*, "in the work cited")

and "loc. cit." (for *loco citato*, "in the place cited") have almost disappeared. Identification by author — or by author and short title, if necessary — is preferable.

FOOTNOTING INTERVIEWS, LECTURES, LETTERS

[25] Interview with Alan Shestack, Director, Museum of Fine Arts, Boston, July 12, 1988.

[26] Howard Saretta, ''Masterpieces from Africa,'' Tufts University, May 13, 1988.

[27] Information in a letter to the author, from James Cahill, University of California, Berkeley, Mar. 17, 1988.

BIBLIOGRAPHY

A bibliography is a list of the works cited or, less often, a list of all the relevant sources. (There is rarely much point in the second sort; if you haven't made use of a particular book or article, why list it?) Normally a bibliography is given only in a long manuscript such as a research paper or a book, but instructors may require a bibliography even for a short paper if they wish to see at a glance the material that the student has used. In this case a heading such as "Works Consulted" or "Works Cited" is less pretentious than "Bibliography."

If the bibliography is extensive, it may be advisable to divide it into two parts, Primary Materials and Secondary Materials (see page 147), or even into several parts, such as Theological Background, Iconographic Studies, Marxist Interpretations, and so forth.

Because a bibliography (or each part of a bibliography) is arranged alphabetically by author, the author's *last name is given first*. If a work is by more than one author, it is given under the first author's name; this author's last name is given first, but the other author's or authors' names follow the normal order of first name first. (See the entry under Rosenfield, p. 132).

Anonymous works are sometimes grouped at the beginning, arranged alphabetically under the first word of the title (or the sec-

ond word, if the first word is *A, An,* or *The*), but the recent ten-
dency has been to list them at the appropriate alphabetical place,
giving the initial article, if any, but alphabetizing under the next
word. Thus an anonymous essay entitled "A View of Leonardo"
would retain the "A" but would be alphabetized under V.

In addition to giving the last name first, a bibliographic entry
differs from a footnote in several other ways. For example, a bib-
liographic entry does not put parentheses around the place of pub-
lication, the publisher, and the date. In typing an entry, begin flush
with the left-hand margin; if the entry runs over the line, indent
the subsequent lines of the entry five spaces. Double-space between
entries. (Some manuals suggest double-spacing throughout; check
with your instructor.)

> *A book by one author:*
>
> Caviness, Madeline Harrison. <u>The Early Stained Glass
> of Canterbury Cathedral</u>. Princeton: Princeton Uni-
> versity Press, 1977.

Note: Princeton needs no further identification, but if the city is
obscure, or may be confused with another city of the same name
(e.g., Cambridge, Massachusetts, and Cambridge, England), add
the necessary additional information.

> *A book by more than one author:*
>
> Rosenfield, John M., and Elizabeth ten Grotenhuis.
> <u>Journey of the Three Jewels: Japanese Buddhist
> Paintings from Western Collections</u>. New York: Asia
> Society, 1979.

Notice in this entry that although the book is alphabetized under
the *last name* of the *first* author, the name of the second author is
given in the ordinary way, first name first.

> *An essay or other work within an edited volume:*
>
> Schapiro, Meyer. ''Style,'' in <u>Aesthetics Today</u>. Ed.
> Morris Philipson. New York: New American Library,
> 1974, pp. 81–113.

Two or more works by the same author:

Cahill, James. <u>Chinese Painting</u>. Geneva: Skira, 1960.
----------. <u>Scholar Painters of Japan: The Nanga
School</u>. New York: Asia House, 1972.

The horizontal line (ten hyphens, followed by a period and then
two spaces) indicates that the author (in this case James Cahill) is
the same as in the previous item; multiple titles by one author are
arranged alphabetically, as here where the title beginning *Chinese*
precedes *Scholar.*

Encyclopedia articles:

''Baroque.'' <u>The New Columbia Encyclopedia</u>. 4th ed.

Jones, Henry Stuart. ''Roman Art.'' <u>Encyclopaedia
Britannica</u>. 11th ed.

''Picasso, Pablo (Ruiz y).'' <u>Encyclopaedia Britannica:
Micropaedia</u>. 1978 ed.

The first and third of these three encyclopedia articles are unsigned,
so the articles are listed under their titles. The second is signed, so
it is listed under its author. Note that an encyclopedia does not
require volume or page, or place or date of publication; the edition,
however, must be identified somehow, and usually the date is the
best identification.

An introduction to a book by another author:

Clark, Kenneth. Intro. to James Hall, <u>Dictionary of
Subjects and Symbols in Art</u>, 2d ed. New York: Harper
& Row, 1979.

The last entry suggests that the student made use of the introduc-
tion, rather than the main body, of the book; if the body of the
book were used, the book would be alphabetized under H for Hall,
and the title would be followed by: Intro. Kenneth Clark.

An edition:

Rossetti, Dante Gabriel. <u>Letters of Dante Gabriel Rossetti</u>. Ed. Oswald Doughty and J. R. Wahl. 4 vols. Oxford: Clarendon, 1965.

A periodical:

Gilbert, Creighton E. ''Some Findings on Early Works of Titian.'' <u>Art Bulletin</u>, 57 (1980), 36–75.

A newspaper:

''Museum Discovers Fake.'' <u>New York Times</u>, January 21, 1980, Sec. D, p. 29, col. 2.

Romero, Maria. ''New Sculpture Unveiled.'' <u>Washington Post</u>, March 18, 1980, p. 6, col. 4.

Because the first of these newspaper articles is unsigned, it is alphabetized under the first word of the title; because the second is signed, it is alphabetized under the author's last name.

A collection or anthology:

Goldwater, Robert, and Marco Treves, eds. <u>Artists on Art</u>. New York: Pantheon, 1945.

This entry lists the collection alphabetically under the first editor's last name. Notice that the second editor's name is given first name first. A collection may be entered either under the editor's name or under the first word of the title.

A book review:

Galantic, Ivan. Rev. of <u>Leon Battista Alberti: Universal Man of the Early Renaissance</u>, by Joan Gadol. <u>Art Quarterly</u>, 34 (1971), 482–85.

SOME CONVENTIONS OF USAGE

The Apostrophe

1. To form the possessive of a name, the simplest (and perhaps the best) thing to do is to add *'s*, even if the name already ends with a sibilant *(-s, -cks, -x, -z)*. Thus:

> El Greco's colors
> Rubens's models
> Velázquez's subjects
> Augustus John's sketches (his last name is *John*)
> Jasper Johns's recent work (his last name is *Johns*)

But some authorities say that to make the possessive for names ending in a sibilant, only an apostrophe is added (without the additional *s*) — Velázquez would become Veláquez', and Moses would become Moses' — unless (1) the name is a monosyllable (e.g., Jasper Johns would still become Johns's) or (2) the sibilant is followed by a final *e* (Horace would still become Horace's). Note that despite the final *s* in Degas and the final *x* in Delacroix, these names do not end in a sibilant (the letters are not pronounced), and so the possessive must be made by adding *'s*.

2. Don't add *'s* to the title of a work to make a possessive; the addition can't be italicized (underlined), since it is not part of the title, and it looks odd attached to an italicized word. So, not "*The Sower's* colors"; rather, "the colors of *The Sower.*"

3. Don't confuse *its* and *it's*. The first is a possessive pronoun ("Its colors have faded"); the second is a contraction of *it is* ("It's important to realize that most early landscapes were painted indoors"). You'll have no trouble if you remember that the possessive pronoun *its,* like other possessive pronouns such as ours, his, hers, theirs, does *not* use an apostrophe.

Capitalization

Although some writers do not capitalize renaissance, middle ages, romanesque, and so on, most do, even when, for example,

Renaissance is used as an adjective ("Most Renaissance portraits"). But do not capitalize medieval. Most writers do not capitalize classic and romantic — but even if you do capitalize Romantic when it refers to a movement ("Delacroix was a Romantic painter"), note that you should not capitalize it when it is used in other senses ("There is something romantic about ruined temples"). Many writers capitalize the chief events of the Bible, such as the Creation, the Fall, the Annunciation, and the Crucifixion, and also mythological events, such as the Rape of Ganymede and the Judgment of Paris. Again, be consistent.

On capitalization in titles, see pages 111 and 140.

The Dash

Type a dash by typing two hyphens without hitting the space bar before, between, or after. Do not confuse the dash with the hyphen. Here is an example of the dash:

```
New York--not Paris--is the center of the art world
today.
```

Foreign Words and Quotations in Foreign Languages

1. Underline (to indicate italics) foreign words that are not part of the English language. Examples: *sfumato* (an Italian word for a blurred outline), *pai-miao* (Chinese for fine-line work). But such words as chiaroscuro and Ming are not italicized because, as their presence in English dictionaries indicates, they have been accepted into English vocabulary. Foreign names are discussed below.

2. Do not underline a quotation (whether in quotation marks or set off) in a foreign language. A word about foreign quotations: If your paper is frankly aimed at specialists, you need not translate quotations from languages that your readers might be expected to know, but if it is aimed at a general audience, translate foreign quotations, either immediately below the original or in a footnote.

3. On translating the titles of works of art, and on capitalizing the titles of foreign books, see "Titles," pages 139–40.

The Hyphen

1. Use a hyphen to divide a word at the end of a line. Because words may be divided only as indicated by a dictionary, it is easier to end the line with the last complete word you can type than to keep reaching for a dictionary. But here are some principles governing the division of words at the end of a line:

 a. Never hyphenate words of one syllable, such as *called, doubt, through*.
 b. Never hyphenate so that a single letter stands alone: *a-lone, hair-y*.
 c. If a word already has a hyphen, divide it at the hyphen: *anti-intellectual*.
 d. Divide prefixes and suffixes from the root: *pro-vide; paint-ing*.
 e. Divide between syllables. If you aren't sure of the proper syllabification, check a dictionary.

Notice that when hyphenating, you do not hit the space bar before or after hitting the hyphen.

2. Use a hyphen to compound adjectives into a single visual unit: twentieth-century architects (but "She was born in the twentieth century").

Names

1. Dutch van, as in Vincent van Gogh, is never capitalized by the Dutch except when it begins a sentence; in American usage, however, it is acceptable (but not necessary) to capitalize it when it appears without the first name, as in "The paintings of Van Gogh." But: "Vincent van Gogh's paintings." Names with *van* are commonly alphabetized under the last name, e.g., under G for Gogh.

2. French de is not used (De Gaulle was an exception) when the first name is not given. Thus, the last name of Georges de La Tour is La Tour, *not* de La Tour. But when *de* is combined with the definite article, into *des* or *du,* it is given even without the first name. *La* and *Le* are used even when the first name is not given, as in Le Nain.

3. Spanish de is not used without the first name, but if it is combined with *el* into *Del,* it is given even without the first name.

4. Names of deceased persons are never prefaced with Mr., Miss, Mrs., or Ms. — even in an attempt at humor.

5. Names of women used to be prefaced by a polite Miss or Mrs., but the convention today is to treat them like men's names, that is, to give them no title.

6. First names are used for many writers and artists of the Middle Ages and Renaissance (examples: Dante, for Dante Alighieri; Michelangelo, for Michelangelo Buonarroti; Piero, for Piero della Francesca; Rogier, for Rogier van der Wyeden), and usually these are even alphabetized under the first name. But do not adopt a chatty familiarity with later people: Picasso, not Pablo. Exception: Because van Gogh often signed his pictures "Vincent," some writers call him Vincent.

Sexist Language

1. It is awkward to write "he or she," or "his or her," but the implicit male chauvinism in the generic use of the male pronoun ("An architect should maintain his independence") may be more offensive than the awkwardness of "he or she" or "his or her." Do what you can to avoid the dilemma. Sometimes you can use the plural *their* ("Architects should maintain their independence"). Or eliminate the possessive: "An architect should be independent."

2. Because *man* and *mankind* strike many readers as sexist when used in such expressions as "man's art" or "the greatness of mankind," consider using such words as *human being, person,* and *people.*

Spelling

Experience has shown that the following words are commonly misspelled in papers on art. If the spelling of one of these words strikes you as odd, memorize it.

altar (noun)	Crucifixion	independent
alter (verb)	deity (*not* diety)	parallel
background	dimension	prominent
connoisseur	dominant	recede
contrapposto	exaggerate	shepherd

| silhouette | subtly | vertical (*not* |
| spatial | symmetry | verticle) |

Be careful to distinguish the following:

affect, effect *Affect* is usually a verb, meaning (1) "to influence, to produce an effect, to impress," or (2) "to pretend, to put on," as in "He affected to enjoy the exhibition." Psychologists use it as a noun for "feeling" ("The patient experienced no affect"), but leave this word to psychologists. *Effect,* is a verb, means "to bring about" ("The workers effected the rescue in less than an hour"). As a noun, *effect* means "result" ("The effect of his work was negligible").

capital, capitol A *capital* is the uppermost member of a column or pilaster; it also refers to accumulated wealth, or to a city serving as a seat of government. A *capitol* is a building in which legislators meet, or a group of buildings in which the functions of government are performed.

eminent, immanent, imminent *Eminent,* "noted, famous"; *immanent,* "remaining within, intrinsic"; *imminent,* "likely to occur soon, impending."

its, it's *Its* is a possessive ("Its origin is unknown"); *it's* is short for *it is* ("It's too short").

lay, lie To *lay* means "to put, to set, to cause to rest" ("Lay the glass on the print"). To *lie* means "to recline" ("Venus lies on a couch").

loose, lose *Loose* is an adjective ("The nails in the frame are loose"); *lose* is a verb ("Don't lose the nails").

precede, proceed To *precede* is to come before in time; to *proceed* is to go onward.

principal, principle *Principal* as an adjective means "leading," "chief"; as a noun it means a leader (and, in finance, wealth). *Principle* is only a noun, "a basic truth," "a rule," "an assumption."

Titles

1. On the form of the title of a manuscript essay, see page 111.

2. On underlining titles of works of art, see the next section, "Underlining."

3. Some works of art are regularly given with their titles in foreign languages (Goya's *Los Caprichos*, the Limbourg Brothers' *Les Très Riches Heures du Duc de Berry*, Picasso's *Les Demoiselles d'Avignon*), and some works are given in a curious mixture of tongues (Cézanne's *Mont Sainte-Victoire Seen from Bibémus Quarry*), but the vast majority are given with English titles: Picasso's *The Old Guitarist*, Cézanne's *Bathers*, Millet's *The Gleaners*. In most cases, then, it seems pretentious to use the original title.

4. Capitalization in foreign languages is not the same as in English. If you give a title — of a book, essay, or work of art — in French, capitalize the first word and all proper nouns. If the first word is an article, capitalize also the first noun and any adjective that precedes it. Examples: *Le Dejeuner sur l'herbe; Les Très Riches Heures du Duc de Berry*. If you give a title in German, follow German usage; for example, capitalize the pronoun *Sie* ("you"), but do not capitalize words that are not normally capitalized in German. If you give a title in Italian, capitalize only the first word and names of people and places.

Underlining

Underline (to indicate italics) titles of works of art, other than architecture: Michelangelo's *David*, van Gogh's *Sunflowers*, but the Empire State Building, the Brooklyn Bridge, the Palazzo Vecchio. Also underline titles of books other than holy works: *Art and Illusion*, *The Odyssey*, Genesis, the Bible, the Koran. For further details about biblical citations, see page 118. Also underline foreign words, but do not underline quotations from foreign languages (see p. 136).

7

The Research Paper

A NOTE ON ART-HISTORICAL RESEARCH AND ART CRITICISM

It is sometimes argued that there is a clear distinction between scholarship (or art-historical research) and criticism (or appreciation). In this view, scholarship gives us information about works of art and uses works of art to enable us to understand the thought of a period; criticism gives us information about the critic's feelings, especially the critic's evaluation of the work of art. Art history, it has been said, is chiefly fact finding, whereas art criticism is chiefly fault finding. And there is some debate about which activity is the more worthwhile. The historical scholar may deprecate evaluative criticism as mere talk about feelings, and the art critic may deprecate scholarly art-historical writing as mere irrelevant information. We should look further, then, at historical scholarship and criticism, and at the relation between them.*

*This simple polarity is called into doubt by a third kind of activity, connoisseurship, for the connoisseur identifies and evaluates works of art. Erwin Panofsky, in *Meaning in the Visual Arts* (Garden City, N. Y.: Doubleday, 1955), suggests that the connoisseur differs from the art historian not so much in principle as in emphasis; the connoisseur's opinions (e.g., "Rembrandt around 1650"), like the historian's, are verifiable. The difference is this: "The connoisseur might be defined as a laconic art historian, and the art historian as a loquacious connoisseur" (p. 20). But elsewhere (p. 322) in his book Panofsky distinguishes

The art historian is sometimes viewed as a sort of social scientist, reconstructing the conditions and attitudes of the past through documents. (The documents, of course, include works of art as well as writings.) In studying Cubism, for example, the supposedly dispassionate art historian does not prefer one work by Braque to another by Braque, or Picasso to Braque or the other way around. The historian's job, according to this view, is to explain how and why Cubism came into being, and value judgments are considered irrelevant.

The art critic, on the other hand, is supposedly concerned not with verifiable facts but with value judgments. Sometimes these judgments can be reduced to statements such as "This work by Braque is better than that work by Picasso," or "Picasso's late works show a falling-off," and so on, but even when critics are not so crudely awarding A's and B's and C's, acts of evaluation lie behind their choice of works to discuss. Intrigued by a work, they usefully call our attention to qualities in it that evoke a response, helping us to see what the work has to offer us. As they do so, they are usually also calling our attention to the degree to which the work corresponds to certain standards or values, for instance complexity or unity or sincerity or innovativeness. Critics often claim, or assume, that — like historians — they are impartial; their judgments, they may say, are based on external standards such as those just specified. The distinction, then, between objectivity (supposedly the property of the historian) and subjectivity (supposedly the property of the critic) is thus called into doubt.

It is probably true, of course, that the root of criticism is a feeling, even a passion, which is then made acceptable by being set forth in a carefully reasoned account. But it must then be added

between art history on the one hand and, on the other, "aesthetics, criticism, connoisseurship, and 'appreciation.'" Perhaps we can retain Panofsky's definition of the connoisseur as a "laconic art historian," and say that the connoisseur's specialty is a sensitivity to artistic traits, and that the art historian possesses the knowledge of the connoisseur, i.e., a knowledge of what is genuine and of when it was made, and then goes on (by analyzing forms and by relating them chronologically) to explain the changes that have occurred in the ways that artists have seen.

that the root of much historical writing is also a feeling or intuition — a hunch perhaps that a stained glass window in a medieval cathedral may be a late replacement, or that photography did not influence the paintings of Degas as greatly as is usually thought. The historian then follows up the hunch by scrutinizing the documents and by setting forth — like the critic — a reasoned account.

It is doubtful, then, that historical scholarship and esthetic criticism are indeed two separate activities; or, to put it a little differently, we can ask if scholarship is really concerned exclusively with verifiable facts, and, on the other hand, if criticism is really concerned exclusively with unverifiable responses, that is, only with opinions. If scholarship limited itself to verifiable facts, it would have little to deal with; the verifiable facts usually don't go far enough. Suppose that a historian who is compiling a catalog of Rembrandt's work, or who is writing a history of Rembrandt's development, is confronted by a drawing attributed to Rembrandt. External documentation is lacking: No letter describes the drawing, gives a date, or tells us that the writer saw Rembrandt produce it. The historian must decide whether the drawing is by Rembrandt, by a member of Rembrandt's studio, by a pupil but with a few touches added by the master, or is perhaps an old copy or even a modern forgery. Scholarship (e.g., a knowledge of paper and ink) may reveal that the drawing is undoubtedly old, but questions still remain: Is it by the master or by the pupil or by both? (The problem is extremely complex, because Rembrandt apparently was a great teacher, one who could inspire his students to produce works of exceptional beauty. Still, there is much to be said for holding to the axiom that great works of art are produced only by great masters. It is hard to believe that a mediocrity occasionally rises to the heights of genius, no matter how exceptional his or her teacher. But on the other hand, it seems certain that a master can have an off-day.)

Even the most scrupulous historians must bring their critical sense into play, and offer conclusions that go beyond the verifiable facts — conclusions that are ultimately based on an evaluation of the work's quality, a feeling that the work is or is not by Rembrandt. Art historians try to work with scientific objectivity, but because the facts are often inconclusive, much in their writing is inevitably (and properly) an articulation of a response, a rational

explanation of feeling that is based on a vast accumulation of experience. Another example: A writer's decision to include in a textbook a discussion of a given artist or school of art is probably a judgment based ultimately on the feeling that the matter is or is not worth discussing, is or is not something of importance or value. And the decision to give Vermeer more space than Caspar Netscher is an esthetic decision, for Netscher was, in his day, more influential than Vermeer. Indeed, art history has worked along these lines from its beginnings in *Lives of the Most Excellent Painters, Sculptors and Architects* by Giorgio Vasari (1511–74). Vasari says that he disdained to write a "mere catalog," and that he did not hesitate to "include [his] own opinion" everywhere and to distinguish between the good, the better, and the best.

And, on the other hand, even critics who claim that they are concerned only with evaluation, and who dismiss all other writing on art as sociology or psychology or gossip, bring some historical sense to their work. The exhibitions that they see have usually been organized by scholars, and the accompanying catalogs are often significant scholarly works; it is virtually impossible for a serious museumgoer not to be influenced, perhaps unconsciously, by art historians. When, for example, critics praise the Cubists for continuing the explorations of Cézanne, and damn John Singer Sargent for contributing nothing to the development of art, they are doing much more than expressing opinions; they are drawing on their knowledge of art history, and they are also echoing the fashionable view that a work of art is good if it marks an advance in the direction that art happens to have taken.

Probably it is best, then, not to insist on the distinction between scholarship and criticism, but to recognize that most writing about art is a blend of both. True, sometimes a piece of writing emphasizes the facts that surround the work (e.g., sources, or the demands of the market), showing us how to understand what people once thought or felt; and sometimes it emphasizes the reasons why the writer especially values a particular work, showing the work's beauty and significance for us. But on the whole the best writers on art do both things, and they often do them simultaneously.

Consider, as an example, Julius S. Held's article, "The Case Against the Cardiff 'Rubens' Cartoons," published in *The Burling-*

ton Magazine, March 1983. Four full-scale cartoons (large drawings) for tapestries were acquired in 1979 by the National Museum of Wales as works by Rubens, but their attribution has been doubted. In the second paragraph of his article, Professor Held comments,

> When I first saw the photographs of the cartoons, and even more so after I had seen them in their setting in Cardiff (27th July 1980), I failed to notice anything that would justify the extraordinary claims made for them. That they were Flemish paintings of the seventeenth century no one could deny. They could also be of special interest as cartoons painted on paper, a category of works that must have existed in great quantity, though few have survived. Yet an attribution to Rubens, as the author of their design as well as the actual executant seemed to me highly questionable and certainly not at all self-evident.

Obviously Held is suggesting that the works do not look like works by Rubens, and in the words "the extraordinary claims made for them" we hear a strong implication that they are not good enough to be by Rubens. So we begin with evaluation, taste, perhaps subjective judgment, but judgment made by a trained eye.

Held goes on to buttress this judgment with other criteria, of a more objective kind. Technically, the cartoons are unprecedented in Rubens's oeuvre. They are done in watercolor on paper, a medium he never used on this scale; even in small drawings watercolor alone is rarely employed. The attribution, hence, of the disputed cartoons to Rubens is unlikely on this ground alone. Held proceeds to ask himself on what basis these cartoons were attributed to Rubens in the first place. The main argument in favor was based on the existence of two *modelli,* painted in oil and depicting actions similar to those of the two cartoons. These *modelli* are indeed by Rubens, but they cannot be used in support of the attribution of the cartoons. Why? Because in composition these *modelli* differ radically from the cartoons, whereas in all the instances in which we know Rubens's *modelli* for tapestry cartoons, the *modelli* and the cartoons agree with each other in all essential respects. In disengaging the *modelli* from the cartoons, Held also uses an iconographic argument: The cartoons depict incidents from the life of Aeneas, but the *modelli* illustrate scenes from the life of Romulus.

In short, during the course of his argument, Held introduces

historical data in support of critical judgments. His final words make this clear: "The purpose of my paper is served . . . if it succeeds to remove Rubens's name from four paintings that are not worthy to carry it."

WHAT RESEARCH IS

Because a research paper requires its writer to collect the available evidence — usually including the opinions of earlier investigators — one sometimes hears that a research paper, unlike a critical essay, is not the expression of personal opinion. But such a view is unjust both to criticism and to research. A critical essay is not a mere expression of personal opinion; to be any good it must offer evidence that supports the opinions, thus persuading the reader of their objective rightness. And a research paper is largely personal, because the author continuously uses his or her own judgment to evaluate the evidence, deciding what is relevant and convincing. A research paper is not merely an elaborately footnoted presentation of what a dozen scholars have already said about a topic; it is a thoughtful evaluation of the available evidence, and so it is, finally, an expression of what the author thinks the evidence adds up to.*

You may want to do some research even for a paper that is primarily critical. Consider the difference between a paper on the history of Rodin's reputation and a paper offering a formal analysis of a single work by Rodin. The first of these, necessarily a research paper, will require you to dig into books and magazines and newspapers to find out about the early response to his work; but even if you are writing a formal analysis of a single piece, you may want to do a little research into, for example, the source of the pose. The point is that writers must learn to use source material thoughtfully, whether they expect to work with few sources or with many.

*Because footnotes may be useful or necessary in a piece of writing that is *not* a research paper (such as this chapter), and because I want to emphasize the fact that a thoughtful research paper requires more than footnotes, I have put the discussion of footnotes in Chapter 6 on pages 123–131.

Though research sometimes requires one to read tedious material, or material that, however interesting, proves to be irrelevant, those who engage in research feel, at least at times, an exhilaration, a sense of triumph at having studied a problem thoroughly and at having arrived at conclusions that at least for the moment seem objective and irrefutable. Later, perhaps, new evidence will turn up that will require a new conclusion, but until that time, one may reasonably feel that one knows *something*.

PRIMARY AND SECONDARY MATERIALS

The materials of most research are conventionally divided into two sorts, primary and secondary. The primary materials or sources are the subject of study, the secondary materials are critical and historical accounts already written about these primary materials. For example, if you want to know whether or not Rodin was influenced by Michelangelo, you will look at works by both sculptors, and you will read what Rodin said about his work as a sculptor. In addition to these primary sources, you will also read secondary material such as modern books on Rodin. There is also material in a sort of middle ground: what Rodin's friends and assistants said about him. If these remarks are thought to be of compelling value, especially because they were made during Rodin's lifetime or soon after his death, they can probably be considered primary materials. And, of course, for a work such as Rodin's *Monument to Balzac* (1897), the novels of Balzac can be considered primary materials.

FROM SUBJECT TO THESIS

First, a subject. No subject is undesirable. As G. K. Chesterton said, "There is no such thing on earth as an uninteresting subject; the only thing that can exist is an uninterested person." Research can be done on almost anything that interests you, though you should keep in mind two limitations. First, materials for research on recent works may be extremely difficult to get hold of,

since crucial documents may not yet be in print and you may not have access to the people involved. And, second, materials on some subjects may be unavailable to you because they are in languages you can't read or in publications that no nearby library has. So you probably won't try to work on the stuff of today's news — for example, the legal disposition of the works of a sculptor whose will is now being contested; and (because almost nothing in English has been written on it) you won't try to work on the date of the introduction into Japan of the image of the Buddha at birth. But no subject is too trivial for study: Newton, according to legend, wondered why an apple fell to the ground.

You cannot, however, write a research paper on subjects as broad as Buddhist art, or Michelangelo, or the Oriental influence on Western art. You have to focus on a much smaller area within such a subject. Let's talk about the Oriental influence on Western art. You might narrow your topic, so that you concentrate on the influence of Japanese prints on van Gogh (or on Toulouse-Lautrec, or on Mary Cassatt), or on the influence of calligraphy on Mark Tobey, or on the influence of Buddhist sculpture on Jo Davidson. Your own interests will guide you to the topic — the part of the broad subject — that you wish to explore, and you won't know what you wish to explore until you start exploring. Picasso has a relevant comment: "To know what you want to draw, you have to begin drawing. If it turns out to be a man, I draw a man."

But, of course, even though you find you are developing an interest in an appropriately narrow topic, you don't know a great deal about it; that's one of the reasons you are going to do research on it. Let's say that you happen to have a Japanese print at home, and your instructor's brief reference to van Gogh's debt to Japanese prints has piqued your interest. You may want to study some pictures and do some reading now. As an art historian (at least for a few hours each day for the next few weeks), at this stage you think you want to understand why van Gogh turned to Japanese art (the explanation will probably include some relatively remote causes as well as what historians have called "releasers" or "triggers"), and what the effect of Japanese art was on his own work. Possibly your interest will shift to the influence of Japan on van Gogh's friend, Gauguin, or even to the influence of Japanese prints on David Hockney in the 1970s. That's all right; follow your interests. Exactly what you will focus on, and exactly what your *thesis,* or point

of view, will be, you may not know until you do some more reading. But how do you find the relevant material?

FINDING THE MATERIAL

You may already happen to know of some relevant material that you have been intending to read, or you can find the titles of some of the chief books by looking at the bibliography in such texts as H. W. Janson's *History of Art* or Spiro Kostof's *History of Architecture,* but if these do not prove useful and you are at a loss about where to begin, consult the card catalog of your library, the appropriate guides to articles in journals, and certain reference books listed below.

The Card Catalog

The card catalog has cards arranged alphabetically not only by author and title but also by subject. It won't have a heading for "The Influence of Japanese Prints on van Gogh," of course, but it will have one for "Art: Japanese" (this will then be broken down into periods), and there will also be a subject heading for "Prints, Japanese," after which will be a card for each title that is in the library's collection. And, of course, you will look up van Gogh (who, it will probably turn out, will be listed under Gogh), where you will find cards listing books by him (e.g., collections of his letters) and about him.

Scanning Encyclopedias, Books, and Book Reviews

Having checked the card catalog and written down the relevant data (author, title, call number), you can begin to scan the books, or you can postpone looking at the books until you have found some relevant articles in periodicals. For the moment, let's postpone the periodicals.

If you know almost nothing about your topic, you may want to begin by reading the relevant articles in *Encyclopedia of World Art,* originally a fifteen-volume work published by McGraw-Hill in

1959–68, but now with two supplementary volumes (1983 and 1987) updating the bibliographies. (Don't confuse this seventeen-volume work with *McGraw-Hill Dictionary of Art,* a five-volume set.) *Encyclopedia of World Art* includes articles on broad subjects, such as "Genre and Secular Subjects," which can provide excellent overviews. Be sure to check the index — volume 15 — in order to find all of the relevant material in the *Encyclopedia,* and be sure to check the two supplementary volumes, volumes 16 and 17.

For certain topics, such as early Christian symbolism, *New Catholic Encyclopedia* (fifteen volumes) is a good place to begin. *Encyclopedia Americana* and *Encyclopaedia Britannica* also can be useful.

Let's assume that you have glanced at some entries in an encyclopedia, or perhaps have decided that you already know as much as would be included in such an introductory work, and you now want to investigate the subject more deeply. Put a bunch of books in front of you, and choose one as an introduction. How do you choose one from half a dozen? Partly by its size — choose a fairly thin one — and partly by its quality. Roughly speaking, it should be among the more recent publications, or you should have seen it referred to (perhaps in the textbook used in your course) as a standard work on the subject. The name of the publisher is at least a rough indication of quality: A book or catalog published by a major museum, or by a major university press, ought to be fairly good.

When you have found the book that you think may serve as your introductory study, read the preface in order to get an idea of the author's purpose and outlook, scan the table of contents in order to get an idea of the organization and the coverage, and scan the final chapter or, if the book is a catalog of an exhibition, the last few pages of the introduction, where you may be lucky enough to find a summary. The index, too, may let you know if the book will suit your purpose by showing you what topics are covered and how much coverage they get. If the book still seems suitable, scan it.

At this stage it is acceptable to trust one's hunches — you are only going to scan the book, not buy it or even read it — but you may want to look up some book reviews to assure yourself that the book has merit. There are three especially useful indexes to book reviews:

Book Review Digest (published from 1905 onward)
Book Review Index (1965–)
Art Index (1929–)

Book Review Digest includes brief extracts from the reviews, chiefly in relatively popular (as opposed to scholarly) journals. Thus if an art book was reviewed in the *New York Times Book Review,* or in *Time* magazine, you will probably find something (listed under the author of the book) in *Book Review Digest.* Look in the volume for the year in which the book was published, or in the next year. But specialized books on art will probably be reviewed only in specialized journals on art, and these are not covered by *Book Review Digest.*

You can locate reviews by consulting *Book Review Index* (look under the name of the author of the book) or by consulting *Art Index.* (In the early volumes of *Art Index,* reviews were listed, alphabetically by the author of the review, throughout the volumes, but since 1973–74 reviews have been listed at the rear of each issue, alphabetically by author and subject.) Scholarly reviews sometimes appear two or even three years after the publication of the book, so for a book published in 1980 you probably will want to consult issues of *Book Review Index* and *Art Index* for as late as 1983.

When you have located some reviews, read them and then decide whether you want to scan the book. Of course, you cannot assume that every review is fair, but a book that on the whole gets good reviews is probably at least good enough for a start.

By quickly reading such a book (take few or no notes at this stage), you will probably get an overview of your topic, and you will see exactly what part of the topic you wish to pursue.

Indexes to Published Material

An enormous amount is published in books, magazines, and scholarly journals; you cannot start looking at random, but fortunately there are indexes. The most widely used indexes are these:

Readers' Guide to Periodical Literature (1900–)
Art Index (1929–)
Répertoire d'art at d'archéologie (1910–)

RILA (1975–)

ARTbibliographies MODERN (1969–)

Reader's Guide indexes more than a hundred of the more familiar magazines — such as *Atlantic, Nation, Scientific American, Time.* Probably there won't be much for you in these magazines unless your topic is something like "Van Gogh's Reputation Today," or "Popular Attitudes toward Surrealism, 1930–1940," or "Jackson Pollock as a Counter-Culture Hero of '50s America," or some such thing that necessarily draws on relatively popular writing.

Art Index, Répertoire d'art, RILA, and *ARTbibliographies MODERN* are indexes to many of the less popular, more scholarly periodicals — for example, periodicals published by learned societies — and bulletins issued by museums.

Art Index lists material in about 250 periodicals; it does not list books but it does list, at the rear, book reviews under the name of the subject and the author of the book. *Art Index* covers not only painting, drawing, sculpture, and architecture, but also photography, decorative arts, city planning, and interior design — and it covers Africa and Asia as well as Western cultures.

Répertoire d'art lists books as well as articles in some 1,750 periodicals (many of them European), but it excludes non-Western art, and since 1965 it has excluded art before the early Christian period. It also excludes artists born after 1920.

RILA: International Repertory of the Literature of Art lists books as well as articles in some 300 journals. It is especially useful because it includes abstracts, but it covers only post-Classical European art (it begins with the fourth century) and post-Columbian American art.

ARTbibliographies MODERN, concerned with art since 1800, provides abstracts or brief annotations not only of periodical articles concerned with art of the nineteenth and twentieth centuries, but also of exhibition catalogs and books.

Whichever indexes you use, begin with the most recent years and work your way back. If you collect titles of materials published in the last five years, you will probably have as much as you can read. These articles will probably incorporate the significant points of earlier writings. But, of course, it depends on the topic; you may have to — and want to — go back fifty or more years before you find a useful body of material.

Note, too, that if the museum that owns an object also issues publications, the object may be discussed in a publication issued about the time the object was acquired. Thus, if the Cleveland Museum of Art acquired an object in 1950 (the date of acquisition is given on the label next to the work), an issue of *The Bulletin of the Cleveland Museum of Art* in 1950 or 1951 may discuss it.

Caution: Indexes drastically abbreviate the titles of periodicals. Before you put the indexes back on the shelf, be sure to check the key to the abbreviations, so that you know the full titles of the periodicals you are looking for.

Other Guides to Published Materials

There are a great many reference books — not only general dictionaries and encyclopedias but dictionaries of technical words (e.g., *Adeline's Art Dictionary,* reissued as *Adeline Art Dictionary*), and of motifs (e.g., James Hall's *Dictionary of Subjects and Symbols in Art*) and encyclopedias of special fields, such as *Encyclopedia of World Art,* already mentioned on page 149. *Adeline's Art Dictionary,* for example, defines terms used in painting, sculpture, architecture, etching, and engraving. Hall's *Dictionary* is devoted chiefly to classical and biblical themes in Western art: If you look up the Last Supper, you will find two detailed pages on the topic, explaining its significance and the various ways in which it has been depicted since the sixth century. For instance, in the earliest depictions Christ is at one end of the table, but later Christ is at the center. A dog may sit at the feet of Judas, or Judas may sit alone on one side of the table; if the disciples have haloes, Judas's halo may be black. Again, if in Hall's *Dictionary* you look up *cube,* you will find that in art it is "a symbol of stability on which Faith personified rests her foot; . . . Its shape contrasts with the unstable globe of Fortune." James Smith Pierce's *From Abacus to Zeus,* a similar dictionary, includes fewer symbols and shorter discussions (half of one page for the Last Supper), but, unlike Hall's *Dictionary,* it includes definitions of terms used in art, such as *ground line.*

For definitions of the chief terms, and for brief biographies, see Peter and Linda Murray's little *Dictionary of Art and Artists,* or *The Oxford Companion to Art,* edited by Harold Osborne. *The Larousse Dictionary of Painters* accompanies its biographies with illustrations. U. Thieme and F. Becker's *Allgemeines Lexicon der bilden-*

den Künstler, von der Antike bis zur Gegenwart, a thirty-seven-volume compilation (six-volume supplement by H. Vollmer), is the chief biographical dictionary; it covers painters and sculptors from ancient times to the early twentieth century, but to use it one must be able to read German. For artists of the twentieth century, the best general reference works are *The Oxford Companion to Twentieth-Century Art,* edited by Harold Osborne, and *Contemporary Artists.*

How do you find such books? Perhaps the best guide, partly because it is the most recent and therefore includes many titles not found in older books, is

> Lois Swan Jones, *Art Research Methods and Resources,* 2d ed. (1984)

Among other useful guides to the numerous books on art are these:

> E. Louise Lucas, *Art Books: A Basic Bibliography on the Fine Arts* (1968)
>
> Bernard Goldman, *Reading and Writing in the Arts: A Handbook,* rev. ed. (1978)
>
> Gerd Muehsam, *Guide to Basic Information Sources in the Visual Arts* (1978)
>
> Donald L. Ehresmann, *Fine Arts: A Bibliographic Guide to Basic Reference Works, Histories, and Handbboks,* 3rd ed. (1987)
>
> Etta Arntzen and Robert Rainwater, *Guide to the Literature of Art History* (1980)
>
> W. Eugene Kleinbauer and Thomas P. Slavens, *Research Guide to the History of Western Art* (1982)

What about reference books in other fields? The best guide to reference books in all sorts of fields is *Guide to Reference Books,* tenth edition (1986), compiled by Eugene P. Sheehy and others.

There are guides to all of these guides: reference librarians. If you don't know where to turn to find something, turn to the librarian.

READING AND TAKING NOTES

As you read, you will, of course, find references to other publications, and you will jot these down so that you can look at them later. It may turn out, for example, that a major article was pub-

lished twenty years ago and that most later writing about your topic is a series of footnotes to this piece. You will have to look at it, of course, even though common sense had initially suggested (incorrectly, it seems) that the article would be out of date.

In reading an article or a chapter of a book, read it through but do not take notes while reading it. By the time you reach the end, you may find it isn't noteworthy. Or you may find a useful summary near the end that will contain most of what you can get from the piece. Or you will find that, having a sense of the whole, you can now quickly reread the piece and take notes on the chief points.

When you take notes use four-by-six-inch cards, and write on one side only; material on the back of a card is usually neglected when you come to write the paper. If your notes from a source, on a particular point, run to more than one card (say to three), number each card thus: 1 of 3, 2 of 3, 3 of 3. Use four-by-six cards because the smaller cards (three-by-five) are too small for summaries of useful material, and the larger cards (five-by-seven) invite you to put too much material on one card. Here is a guide to note taking.

1. Write summaries rather than paraphrases; write abridgments rather than restatements, because restatements may turn out to be as long as or longer than the original. There is rarely any point to paraphrasing; generally speaking, either quote exactly (and put the passage in quotation marks, with a notation of the source, including the page number or numbers) or summarize, reducing a page or even an entire article or chapter of a book to a single four-by-six card. Even when you summarize, indicate your source (including the page numbers) on the card, so that you can give appropriate credit in your paper.

2. Of course, in your summary you will sometimes quote a phrase or a sentence — putting it in quotation marks — but quote sparingly. You are not doing stenography; rather, you are assimilating knowledge and you are thinking, and so for the most part your source should be digested rather than engorged whole. Thinking now, while taking notes, will also help you later to avoid plagiarism. If, on the other hand, when you take notes you mindlessly copy material at length, later when you are writing the paper you may be tempted to copy it yet again, perhaps without giving credit. Similarly, if you photocopy pages from articles or books, and then

merely underline some passages, you probably will not be thinking; you will just be underlining. But if you make a terse summary on a note card, you will be forced to think and to find your own words for the idea. Most of the direct quotations that you copy should be effectively stated passages or crucial passages or both. In your finished paper these quotations will provide authority and emphasis. Be sure not to let your paper degenerate into a string of quotations.

3. If you quote but omit some material within the quotation, be sure to indicate the omission by three spaced periods, as explained on page 117. Check the quotation for accuracy, and check the page number you have recorded on your card.

4. *Never* copy a passage by changing an occasional word, under the impression that you are thereby putting it into your own words. Notes of this sort may find their way into your paper, your reader will sense a style other than your own, and suspicions of plagiarism may follow. (For a detailed discussion of plagiarism, see pp. 119–123.)

5. Feel free to jot down your own responses to the note. For example, you may want to say, "Baker made some point 5 yr earlier"; but make certain that later you will be able to distinguish between these comments and the notes summarizing or quoting your source. A suggestion: Surround all comments recording your responses with double parentheses, thus: ((. . .))

6. In the upper corner of each note card, write a brief key — for example, "Van G on color of prints" — so that later you can tell at a glance what is on the card.

WRITING THE PAPER

There remains the difficult job of writing up your findings, usually in 2000–3000 words (eight to twelve double-spaced typed pages). Here is some advice.

1. Begin by rereading your note cards, sorting them into packets by topic. Put together what belongs together. Don't hesitate to reject material that — however interesting — now seems

redundant or irrelevant. In doing your research you quite properly took many notes (as William Blake said, "You never know what is enough unless you know what is more than enough"), but now, in looking your material over, you see that some is unnecessary and so you reject it. Your finished paper should not sandbag the reader; keep in mind the Yiddish proverb, "Where there is too much, something is missing."

After sorting and resorting, you will have a kind of first draft without writing a draft. This business of settling on the structure of your work — the composition of your work, one might say — is often frustrating. Where to begin? Should this go before that? But remember that great artists have gone through greater struggles. If we look at a leaf from one of Raphael's sketchbooks, we find him trying, and trying again, to work out the composition of, say, the Virgin and Child. Nicolas Poussin used a miniature stage, on which he arranged and rearranged the figures in his composition. An X-ray of Rembrandt's *The Syndics of the Cloth Drapers Guild* reveals that he placed the servant in no fewer than four positions (twice at the extreme right, once between the two syndics at the right, and finally in the center) before he found a satisfactory arrangement. You can hardly expect, at the outset, to have a better grasp of your material than Raphael, Poussin, and Rembrandt had of theirs. What Degas said of a picture is true of a research paper: "A good picture requires as much planning as a crime."

2. From your packets of cards you can make a first outline. In arranging the packets into a sequence, and then in sketching an outline (see page 85), you will be guided by your *thesis,* your point. Without a thesis you will have only a lot of note cards, not an essay. This outline will indicate not only the major parts of the essay but also the subdivisions within these parts. Do not confuse this outline with a paragraph outline (i.e., with an outline made by jotting down the topic idea of each paragraph); when you come to write your essay, a single heading in your outline may require two or three or more paragraphs.

3. When you write your first draft, leave lots of space at the top and bottom of each page so that you can add material, which will be circled and connected by arrows to the proper place. On reading your draft you may find that a quotation near the bottom

of page 6 will be more appropriate if it is near the top of page 6. Circle it, and with an arrow indicate where it should go. If it should go on page 4, scissor it out and paste it on page 4. This process is a bit messy, but you will get a strong sense of what your paper sounds like only if you can read a draft with all of the material in the proper place. (The great advantage of using a word processor, of course, is that you can move passages of text without cutting and pasting.) If you move some material in your draft, also move your note cards containing the material, so that if for some reason you later have to double-check your notes, you can find your source easily.

Your opening paragraph — in which you usually will define the problem and indicate your approach — may well be the last thing that you write, for you may not be able to enunciate these ideas clearly until you have learned from drafting the rest of your essay. (On opening paragraphs, see pages 107–109.)

4. Write or type your quotations, even in the first draft, exactly as you want them to appear in the final version. Short quotations (fewer than five lines of prose) are enclosed within quotation marks but are not otherwise set off; longer quotations, however, are set off (triple-space before them and after them), slightly indented, and are *not* enclosed in quotation marks. For more on quotations, see pages 115–119.

5. Include, right in the body of the draft, all of the relevant citations (later these will become footnotes), so that when you come to revise, you don't have to start hunting through your notes to find who said what, and where. You can, for the moment, enclose these citations within diagonal lines, or within double parentheses — anything at all to remind you that they will be your footnotes.

6. Be sure to identify works of art as precisely as possible. Not "Rembrandt's *Self-Portrait*" (he did more than sixty), or even "Rembrandt's *Self-Portait* in the Kunsthistorisches Museum, Vienna" (they own at least two), but "Rembrandt's *Self-Portrait of 1655,* in the Kunsthistorisches Museum, Vienna," or, more usually, "Rembrandt's *Self-Portrait* (1655, Kunsthistorisches Museum, Vienna)." If the exact date is unknown, preface the approximate date with ca., the abbreviation for *circa,* Latin for "about." Example: ca.

1700. Be sure to identify all illustrations with a caption, giving, if possible, artist, title, date, medium, size, and present location. (See pp. 112–113.)

7. Beware of the compulsion to include every note card in your essay. You have taken all these notes, and there is a strong temptation to use them all. But, truth to tell, in hindsight many are useless. Conversely, you will probably find as you write your draft that here and there you need to check a quotation or to collect additional examples. Probably it is best to continue writing your draft, if possible; but remember to insert the necessary material after you get it.

8. As you revise your draft, make sure that you do not merely tell the reader "A says . . . B says . . . C says. . . ." When you write a research paper, you are not merely setting the table with other people's dinnerware; you are cooking the meal. You must have a point, an opinion, a thesis; you are working toward a conclusion, and your readers should always feel they are moving toward that conclusion (by means of your thoughtful evaluation of the evidence) rather than reading an anthology of commentary on the topic.

Thus, because you have a focus, you should say such things as "There are three common views on. . . . The first two are represented by A and B; the third, and by far the most reasonable, is C's view that . . ." or "A argues . . . but . . ." or "Although the third view, C's, is not conclusive, still . . ." or "Moreover, C's point can be strengthened when we consider a piece of evidence that he does not make use of." You cannot merely say, "A says . . ., B says . . ., C says . . .," because your job is not to report what everyone says but to establish the truth of a thesis.

When you introduce a quotation, then, try to let the reader see the use to which you are putting it. "A says" is of little help; giving the quotation and then following it with "thus says A" is even worse. You need a lead-in such as "A concisely states the common view," "B shrewdly calls attention to a fatal weakness," "Without offering any proof, C claims that," "D admits," "E rejects the idea that. . . ." In short, it is usually advisable to let the reader know why you are quoting or, to put it a little differently, how the quotation fits into your argument.

While you were doing your research you may have noticed that the more interesting writers persuade the reader of the validity of their opinions by (1) letting the reader see that they know what of significance had been written on the topic; (2) letting the reader hear the best representatives of the chief current opinions, whom they correct or confirm; and (3) advancing their opinions, by offering generalizations supported by concrete details. Adopt these techniques in your own writing.

Your overall argument, then, is fleshed out with careful summaries and with effective quotations and with judicious analyses of your own, so that by the end of the paper the readers not only have read a neatly typed paper, but they also are persuaded that under your guidance they have seen the evidence, heard the arguments justly summarized, and reached a sound conclusion. They may not become better persons but they are better informed.

9. Make sure that in your final version you state your thesis early, perhaps even in the title (not "Van Gogh and Japanese Prints" but "Van Gogh's Use of Japanese Prints"), but if not in the title, almost certainly in your first paragraph.

10. When you have finished your paper prepare a final copy that will be easy to read. Type the paper (see pp. 111–112), putting the footnotes into the forms given on pages 123–131.

A bibliography or list of works consulted (see pp. 131–134) is usually appended to the research paper, partly to add authority to your paper, partly to give credit to the writers who have helped you, and partly to enable readers to look further into the primary and secondary material if they wish. But if you have done your job well, the reader will be content to leave things where you left them, grateful that you have set things straight.

8
Essay Examinations

WHAT EXAMINATIONS ARE

The first two chapters of this book assume that writing an essay requires knowledge of the subject as well as skill with language. Here a few pages will be devoted to discussing the nature of examinations; perhaps one can write better essay answers when one knows what examinations are.

A well-constructed examination not only measures learning and thinking but also stimulates them. Even so humble an examination as a short-answer quiz is a sort of push designed to move students forward by coercing them to do the assigned looking or reading. Of course, internal motivation is far superior to external, but even such crude external motivation as a quiz can have a beneficial effect. Students know this; indeed, they often seek external compulsion, choosing a particular course "because I want to know something about . . . and I know that I won't do the work on my own." (Teachers often teach a new course for the same reason; we want to become knowledgeable about, say, the Symbolists, and we know that despite our lofty intentions we may not seriously confront the subject unless we are under the pressure of facing a class.)

In short, however ignoble it sounds, examinations force students to acquire knowledge and then to convert knowledge into thinking. Sometimes it is not until preparing for the final examination that students — returning to museums, studying photographs of works of art, rereading the chief texts and classroom notes — see what the course was really about; until this late stage the trees obscure the forest, but now, reviewing and sorting things

"I think you know everybody."

Drawing by Chas. Addams; © 1979 The New Yorker Magazine, Inc.

out — *thinking* about the facts, the data, and the ideas of others — they see a pattern emerge. The experience of reviewing and then of writing an examination, though fretful, can be highly exciting, as connections are made and ideas take on life. Such discoveries about the whole subject matter of a course can almost never be made by writing critical essays on topics of one's own construction, for such topics rarely require a view of the whole. Further, we are more likely to make imaginative leaps when trying to answer questions that other people pose to us than when trying to answer ques-

tions we pose to ourselves. (Again, every teacher knows that students in the classroom ask questions that stimulate the teacher to see things and to think thoughts that would otherwise have been neglected.) And although a teacher's question may cause anxiety, when students confront and respond to it on an examination they often make yet another discovery — a self-discovery, a sudden and satisfying awareness of powers they didn't know they had.

WRITING ESSAY ANSWERS

Let's assume that before the examination you have read the assigned material, marked the margins of your books (but not of the library's books), made summaries of the longer readings and of the classroom comments, visited the museums, reviewed all this material, and had a decent night's sleep. Now you are facing the examination sheet.

Here are seven obvious but important practical suggestions:

1. Take a moment to jot down, as a sort of outline or source of further inspiration, a few ideas that strike you after you have thought a little about the question. You may at the outset realize there are, say, three points you want to make, and unless you jot these down — three key words will do — you may spend all the allotted time on one point.

2. Answer the question: If you are asked to compare two pictures, compare them; don't write two paragraphs on the lives of each painter. Take seriously such words as *compare, summarize,* and especially *evaluate.*

3. You can often get a good start merely by turning the question into an affirmation — for example, by turning "In what ways is the painting of Manet influenced by Goya?" into "Manet's painting is influenced by Goya in at least . . . ways."

4. Don't waste time summarizing at length what you have read unless asked to do so — but, of course, you may have to give a brief summary in order to support a point. The instructor wants to see that you can *use* your reading, not merely that you have done the reading.

5. Budget your time. Do not spend more time on a question than the allotted time.

6. Be concrete. Illustrate your argument with facts — names of painters or sculptors or architects, titles of works, dates, and brief but concrete descriptions.

7. Leave space for last-minute additions. Either skip a page between essays, or write only on the right-hand pages so that on rereading you can add material at the appropriate place on the left-hand pages.

Beyond these general suggestions, it is best to talk about essay examinations by looking at the four most common sorts of questions:

1. a work to analyze
2. a historical question (e.g., "Trace the influence of Japanese art on two European painters of the later nineteenth century"; "Trace the development of Picasso's representations of the Minotaur")
3. a critical quotation to be evaluated
4. a comparison (e.g., "Compare the representation of space in the late works of van Gogh and Gauguin)

A few remarks on each of these types may be helpful.

1. On analysis, see Chapter 2. As a short rule, look carefully at subject matter, line, color (if any), composition, and medium.

2. A good essay on a historical question, like a good lawyer's argument, will offer a nice combination of argument and evidence; that is, the thesis will be supported by concrete details (names, dates, possibly even brief quotations). A discussion cannot be convincing if it does not specify certain works as representative — or atypical — of certain years. Lawyerlike, you must demonstrate (not merely assert) your point.

3. If you are asked to evaluate a critical quotation, read the quotation carefully and in your answer take account of *all* of the quotation. If, for example, the critic has said, "Goya in his etchings always . . . but in his paintings rarely . . . ," you will have to write about etchings and paintings (unless, of course, the instructions on the examination ask you to take only as much of the quotation as

you wish). Watch especially for words like *always, for the most part, never;* that is, although the passage may on the whole approach the truth, you may feel that some important qualifications are needed. This is not being picky; true evaluation calls for making subtle distinctions, yielding assent only so far and no further. Another example of a quotation to evaluate: "Picasso's *Les Demoiselles d'Avignon* [illustrated on p. 13] draws on several traditions, and the result is stylistic incoherence." A good answer not only will specify the traditions or sources (e.g., Cézanne's bathers, Rubens's *The Judgment of Paris,* Renaissance and Hellenistic nudes, pre-Christian Iberian sculptures, Egyptian painting, African tribal art), calling attention to the passages in the painting where each is apparent, but also will evaluate the judgment that the work is incoherent. It might argue, for example, that the lack of traditional stylistic unity is entirely consistent with the newness of the treatment of figures and with the violent eroticism of the subject.

4. On comparisons, see Chapter 3. Because lucid comparisons are especially difficult to write, be sure to take a few moments to jot down a sort of outline so that you know where you will be going. You can often make a good start by beginning with the similarities of the two objects. As you jot these down, you will probably find that your perception of the *differences* will begin to be heightened. In organizing a comparison of two pictures by van Gogh and two by Gauguin, you might devote the first and third paragraphs to van Gogh, the second and fourth to Gauguin. Or you might first treat one painter's two pictures and then turn to the second painter. Your essay will not break into two parts if you announce at the outset that you will treat one artist first, then the other, and if you remind your reader during your treatment of the first artist that certain points will be picked up when you get to the second, and, finally, if during your treatment of the second artist you occasionally glance back to the first.

LAST WORDS

Chance favors the prepared mind.

<div align="right">Louis Pasteur</div>

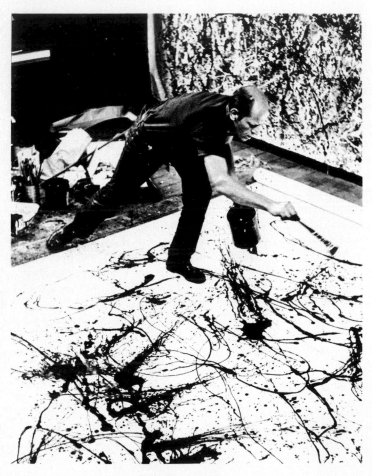

Hans Namuth, *Jackson Pollock Painting,* 1951.

Index